"I was in awe of what I was reading...Jan's remembrances are personal, poignant and moving...She has a way of communicating which lets each reader transpose her life events to theirs...Jan has obviously turned the ordinary, by some people's measure, into the extraordinary."

Lieutenant Colonel Lowell Graham
Commander & Conductor
United States Air Force Band
Washington D.C

❋ ❋ ❋ ❋ ❋ ❋

"Men need to read this book. Jan puts into words sweet mysteries to help us understand our moms, our wives and our daughters the way they need to be understood. I can see myself as I read Jan's words – my childhood, my fears and my joys through her laughter, her tears and her faith. Jan isn't teaching us about sewing quilts here, but about sowing and reaping a great harvest in life."

Chuck Asay, Political Cartoonist
Colorado Springs Gazette Telegraph

❋ ❋ ❋ ❋ ❋ ❋

"I enjoy reading Jan's columns. She does a good job of providing variety and food for thought for her readers."

Dr. John H. Stevens, Senior Minister
First Presbyterian Church, Colorado Springs, CO

"I am a clipper of inspirational articles and I have a folder full of articles by Jan. I am inspired, touched, impressed, and always see life a little better because of the way Jan shares her life and her ideas."

Delia (McCord) Ozburn
Falcon, Colorado

❀ ❀ ❀ ❀ ❀ ❀

"I admire the way Jan captures the 'humanness' of people and how she puts their fears, joys, strengths, inadequacies, fantasies, dreams and memories into words."

Sandra (Trojanovich) Vallier
Peetz, Colorado

❀ ❀ ❀ ❀ ❀ ❀

"Jan has many, many fans. I went to Breckenridge with some friends and they were so complimentary of her writing. I was very pleased to tell them, 'I know Jan and she is my friend.'"

Clarene Durham
Rush, Colorado

❀ ❀ ❀ ❀ ❀ ❀

"Jan is a wonderful, talented lady who certainly knows about life in rural Colorado."

Colorado State Representative Mary Ellen Epps
Colorado Springs, CO

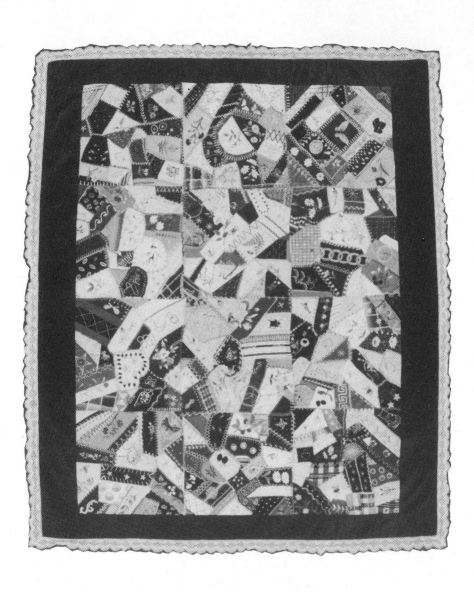

Pieces From My CRAZY QUILT

Pieces From My

Crazy
Quilt

JAN KELLER

Edited By

Monty Gaddy — Amy Holzworth

Warren Parker — Janetta Roberts

**Black Sheep Books
& Publishing**
P.O. Box 325
Calhan, CO 80808

© 1997 by Jan Keller

Crazy Quilt pictured on book cover and throughout text, © Colorado Springs
Pioneers Museum; "Crazy Quilt," circa 1880-1900. Used by permission.

Cover design by Ed Rother.

Book text design, layout and typography by Jan Keller.

Manufactured in the the United States of America.

First Edition
First Printing

ACKNOWLEDGEMENTS
Chuck Asay, Bill Bruhn, Kedrann Dotson, Clarene Durham, Mary Ellen Epps,
Pastor David Folkerts, Donna Fortney, Monty Gaddy, Becky Gaddy,
Connie Goldsmith, Lowell Graham, Jan Hiltner, Amy Holzworth, Joan Lawson,
Fred Lister, Susan Lister, Delia Ozburn, Janet Mock, Warren Parker,
Janetta Roberts, Dr. John H. Stevens, Sandra Vallier and Bonnie Welch

Publisher's Cataloging in Publication
(Prepared by Quality Books Inc.)

Keller, Jan (Janice)
 Pieces from my crazy quilt / Jan Keller.
 p. cm.
 ISBN: 1-8895-79-00-9

 I. Title.

PS3570.E5547P54 1996 814'.54
 QBI96-40158

This Book Is Dedicated To My Husband John, with whom I've shared my life—my crazy quilt.

Sincere Appreciation Is Extended To
Monty & Becky Gaddy
For Their Personal & Professional Support.

Special Thanks To
Scottie H. Fortney
For Challenging Me To Invest In Myself.

Dear Reader,

Quilts provide more than warmth and decoration. They serve as remembrances of loved ones and special events. Their intricate designs are constructed from leftover pieces and patches of a variety of colors into a pattern of fabric that reflects hopes, dreams and frustrations. Small deliberate stitches thread an accumulation of bits and pieces of time that will never come again together into a repository of the memorabilia and details of the maker's life.

My grandma, like many other ladies of her generation, invested countless cold and wintry days making quilts. Her meticulous small stitches also created an eloquent testimony of her love and affection.

I have three quilts Grandma made. One was a wedding gift and the other two were baby gifts commemorating the birth of my sons. I plan to pass these baby gifts on to my grandchildren as an heirloom to be treasured from their Great-Great-Grandmother.

This book, like Grandma's quilts, is constructed from various fragments of my life transposed into a kaleidoscope patchwork representation of who I am and what I've experienced. It includes accounts of dramatic as well as mundane events we all have in common or can relate to.

The bits and pieces of my life contained in this book were originally shared in a weekly column format with readers of Ranchland News between 1985 and 1996. Because this book was written a little bit at a time, that may be the best way to read it. There isn't a plot to uncover. It's just me sharing my joys, dreams, pains, conflicts and sorrows.

I hope reading this book will be like spreading a crazy quilt down on the shore near a tranquil lake. Get comfortable, relax and allow the calm water to transcend and quiet the stress from an otherwise busy day. While sharing thoughts and bologna sandwiches, we'll count the laps of a runner who circles round and around the lake's edge. In between the runner's rounds we'll talk, listen, discover, laugh and live. Then, when our hour of sharing in the sun has ended, every crumb will be gathered up as a memento and the precious memories will be carefully tucked away for safe keeping.

You can spend a lifetime in an hour if you spend it with a friend. Through the bits, pieces and pages of this book I hope you'll discover a kindred spirit and become my friend.

Jan Keller

Contents

Contents

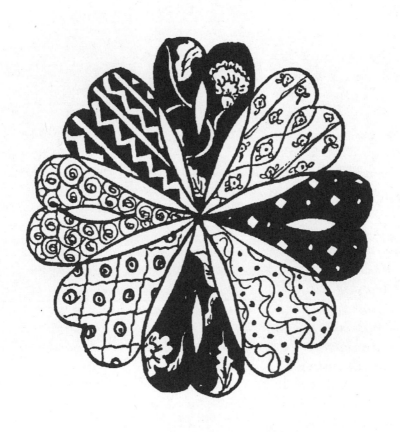

❋ Piecing together a crazy quilt ❋

I was consumed, trying to make sense of a disturbing twist in my life. The annoying turn of affairs hadn't been expected, but there it was, almost out of nowhere. It was up to me to choose a direction, a course to follow.

For a week I wallowed, stewing about something I couldn't change or do anything about. I was unable to turn my head and get on with my life because I couldn't locate a new focus on which to direct my thoughts.

That's when I began sewing on a quilt top. The quilt became my diversion from what had become a taut and stressing situation.

The pattern of my quilt is obvious and predictable. It has a diamond shape pattern formed by blocks cut from six different colors of fabric.

It isn't that way with crazy quilts. They're full of surprises. Crazy quilts use up bits and scraps of any old piece of cloth. There's no rhyme or reason to the resulting eclectic hodgepodge, yet the various pieces somehow miraculously combine and take shape. The result is interesting, unique and, in its own way, beautiful.

Life seems to parallel the crazy quilt concept.

While recently visiting with an area rancher, he talked of how his life might have been different, saying, "My dad almost bought property somewhere else...and if he had, I would have gone to a different school, married someone else and have different children than the ones I have. I probably wouldn't ever have even met my wife. It's hard telling what my life would have been like."

We all make decisions that direct the course of our lives. We can change our minds, but we can't take the seams out and go back to put it all together in a different way. The course is set and time leads on.

During construction, quilts are pulled taut and stressed. The multicolored top is stitched or tied to an inner fiber and a backing that gives strength and purpose. Finally a binding is applied and

the quilt is complete. The intricate pattern can be fully viewed and its warmth enjoyed.

Now I'm eager to get on with life. I'm, eager to continue my crazy, twisting and turning journey.

When I get some distance on down the road, I'll look back and try to catch a glimpse of the pattern. I hope it includes a rich texture of challenging ideas and bright experiences. It would also be satisfying to detect a thread of reason or purpose behind some of the difficulties encountered along the way.

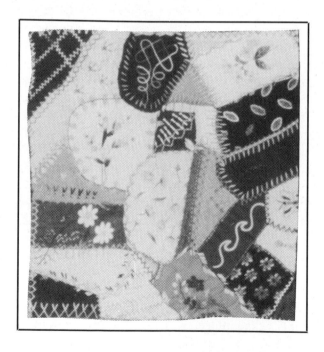

❋ *Common is comfortable* ❋

When I return home after a day away, one of the first and most comforting things I do is put on my old everyday clothes and well-worn shoes.

As the only woman in my household, I am typically alone in my 'kingdom' (more commonly called the kitchen). I'm used to solitude and become nervous if trespassers are present. My family has learned to stay out unless assistance is requested because alteration of my common meal preparation routines will bring on frustration resulting in harsh words falling from my lips.

I have my own style and accustomed manner of cleaning the house. I don't get much cleaning accomplished if I can see my family relaxing and watching TV while I'm trying to work. It's imperative they relax out of my line of vision.

I'm used to using a damp towel for dusting. The moisture on a towel is just the right amount to attract dust without making the furniture wet. I really couldn't dust with anything else. That's what I'm used to.

My familiar bathroom routines are the ones I'm most dependent upon. I have my own style of brushing my teeth. It may be unique and different from how you brush yours, but please don't try to make me change. I'm happy with how I do it.

I have a routine of getting up and dressed in the morning that has become a comfortable habit. It blends with the patterns of others in my family so we all function as a unit with all of us ready to leave the house on time, and usually at about the same time. If any of our individual established routines are altered, even slightly, household chaos results.

In contrast, large social gatherings, comprised of unfamiliar faces, are uncomfortable settings for me. It seems everyone else knows one another and tight little circles of people form around food and beverage.

Others may find these large gatherings fun and an opportunity to mix and mingle, but for me they're an exercise in coping with my

familiar feelings of insecurity. There is no social setting more isolating than feeling alone in a crowd.

Even in that setting, however, I've learned relief is possible. I've discovered comfort and retreat in the powder room–restroom–bathroom–john–or toilet! Call it whatever you like, but in that cubicle, wealth or social status become unimportant. Upon entering, *all* are stripped of false pretense. The reality of our commonness becomes apparent, and haughtiness and facades vanish.

The same people who would look past my existence in the large group are instantly transformed and become remarkably friendly after being reminded of our commonness in the confines of this small, intimate and private environment.

I find commonness comforting and comfortable.

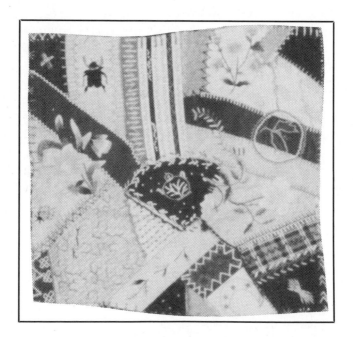

❃ Stressed and distressed foundations ❃

Stress is a condition that develops when people feel they have little or no control over their environment. It is much more stressful to be the passenger in a car being driven recklessly by someone else than to be a driver driving recklessly. The driver thinks he has control over the situation. A passenger has little or no control.

The remodeling of our home became a stressful situation!

The stress went to the very foundation of the building structure as well as the family structure.

Remodeling is very much like paying your money and climbing aboard a roller coaster of highs and lows. Parts of the trip are thrilling. Other parts are the pits.

Having new cupboards installed is thrilling. Having no bed, or even a place to set up a bed, and sleeping on the couch for three months is the pits.

Having a shower, sink and toilet that function is delightful. Having *only* a toilet for two weeks is the pits.

I have wonderful neighbors! I called them and pleaded, "May I come over and use your shower?!" And they obliged.

Other friends lent their support by inviting us over for a much appreciated meal or brought food to us. Maybe that's because for a while our commode was the only plumbing fixture that worked and I jokingly told people I was washing the dishes in the toilet. (Just to set the record straight, I bought a lot of paper plates.)

Oh, we asked for the adventure. It was our decision to build a new house under our old roof, but it was a ride I'll never again set foot on. I always liked carnival rides, but this ride seemed out of control. I wasn't sure when or if it would end. I wasn't even sure who was at the controls.

I got weary of my home and privacy being a work place.

When the workers went to their home, our completed home remained a figment of my imagination. There was no escape to relax and unwind.

My husband John and I had a dream of how our home could be. That dream became a nightmare!

One noon when John came home for lunch, he found me crying. After I told him about everything that was going wrong, he looked me straight in the eye and said, "Look Jan, we've almost got this project completed. You can either hang in there...or you can have a nervous breakdown."

I wanted to tell him, "I'll have the nervous breakdown, thank you!"

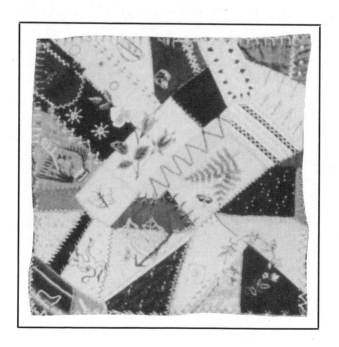

❋ Breakfast blahs ❋

'm not a morning person. I'm not sure there is a time of day when I function efficiently–but I'm positive it's definitely not in the morning!

I am a food person, but not a breakfast food fare person. Typical breakfast entrees are not enticing enough to lure me out of my warm and cozy bed. Getting out of bed, dressed and to the breakfast table only to be greeted by a couple of fried eggs staring up from my plate is more than I can face early in the day.

I find and then spit out every lump in cooked cereal, and the thought of oatmeal makes me gag.

I worked hard to get the kitchen clean before I went to bed. Why would I want to start the day by getting it dirty cooking breakfast?

A little later, maybe ten or eleven o'clock, the thought of a meal is a little more appetizing. It might include chili rellenos with salsa, a hot baked apple smothered with whipped cream, and Danish.

Breakfast in bed is a luxurious indulgence. On those rare occasions, I pretend I'm rich and famous. I've got an incredible imagination!

If the phone rings while I'm eating breakfast in bed, I always tell the truth.

"Oh, did I wake you?" asks the caller.

"No," I say. "I was basking in the warmth of my red satin sheets, sipping a cup of tea and nibbling on a croissant."

With a tinge of green envy the caller replies, "Oh, I'm so sorry to disturb you!"

If the phone rings early enough to catch my husband in bed, the conversation is totally different.

"No! I was awake," he answers. "I've just about finished reading the paper. In fact, Jan has sausage, eggs, hash browns, pancakes and syrup just about ready for breakfast! She's in the kitchen now, squeezing the oranges into juice."

By now I'm awake, leering and laughing at him.

Who does he think he's fooling?

Everyone knows I don't eat breakfast, much less cook it!

❀ Bye, bye birdie ❀

I recently agreed to play a round of golf with my family. I thought it would be a nice way to go on an early morning walk together.

It was a beautiful day, Father's Day to be exact. The sun was bright and there wasn't a cloud in the sky. I could hear the birdies singing.

I've played golf before. In fact–I used to play quite often, at least until I observed some little boys laughing and making jokes about my swing. I didn't think my swing was so bad. What was bad was the way my pregnant abdomen interrupted it. That was seventeen years ago.

I played again, eight years ago, with Cindy Gains, who taught girl's P.E. at our high school. I took my husband's bag of clubs, but I left them in the trunk. Instead, I carried only what I considered necessary–a putter and a couple of balls. (I would have taken only one ball–but thought having an extra would be a good idea, just in case I lost one in the lake.)

I had a great time–at least until my husband found out I played the entire game with *his* putter.

"It really doesn't matter what club I use," I explained. "The ball goes the same distance with any of 'em. I could golf just as well with a croquet mallet."

My husband didn't appreciate my logic and I was banished from using his clubs.

Those early encounters with the game led to my development of a list of conditions which must be met before I'll even consider a round of golf.

• I will not carry a bag of clubs or pull a golf cart.
• I will not golf in the middle of the day, only in the cool of morning or evening.
• I only golf barefooted or in sandals.
• I won't allow my husband to give me pointers on what I did right or wrong.

It should be apparent that the competition of the sport is not my primary interest. I'm into pure recreational creature comfort.

My husband really tries to meet my criteria. Last year for

Mother's Day he bought me a special convertible golf club. With the aid of a coin used like a screwdriver, the club's angle can be changed. My lone club can be transformed into any of the clubs in his complete and heavy bag full. I call it my 'set of club'. (No *real* golfer would be caught dead with it.)

On this recent outing, John, Maury, Mick and I walked into the club house to pay our green fees. They are among the regular customers who seek a perfect round of par golf. The person taking the money recognized them and said, "You and the two boys golfing today?" Then, with a raised eyebrow directing his attention towards me, he continued, "Is *she* golfing with you?"

I don't know what brought on the skepticism. Maybe it was my 'set of club', my sandals or my interest in getting a cold, refreshing can of pop rather than signing in. At any rate, I became aware I was somehow conspicuous.

We had a nice little round of golf. My husband and the boys walked together enjoying the beauty of nature in the great outdoors. I played my own little game of hit the ball and hurry to hit it again. Customarily, the person scoring the lowest on the previous hole gets the honor of teeing off first on the next. I had 'honors' on every hole as a courtesy of keeping their waiting on me to a minimum.

Every once in a while my husband would snicker and say, "I'd say that was a nice shot, but I'm not supposed to comment on your game, so I won't."

Occasionally, he and the boys would get excited about their scores and say, "Wow, I got a birdie!"

I couldn't even keep count of my score on each hole. There wasn't any use–the score card didn't have room for three digit numbers.

I knew our game must be about over. The heat of the day was upon us and my hair was wet from sweat. At least my sandaled open-aired feet weren't sweating. I don't like sweat.

When our game was completed and we were walking off the course, I discovered the birdie. I didn't think it was anything to get excited about. For there on the grass near a large pine tree lay the poor innocent victim of some man's sport and pleasure. A *dead* birdie!

I hope I *never* get a birdie!

Dear Dad,

It's been twenty years since I last saw you, and I miss you.

The last time we were together was early on a sunny November morning. I was seventeen-years-old and you were forty-four. Now I'm thirty-seven, and I've lived more of my life without the benefit of your counsel than with it.

Your last words were, "I love you."

That day was a long one. It was mid-afternoon before the surgeon replacing your defective heart valves came and said the operation hadn't been successful and you were dead.

Since then our lives have gone on. It was difficult at first for Mom, Bob, Lois and I, but now we're all fine. I think you would even be proud of us.

Mom has remarried. She married a wonderful, gentle man. He is a good husband to her and is very accepting of his role of father and grandfather. His genuine love for Mom is evident, and he openly demonstrates his love for all of us. We have grown to return that love. I hope he knows and feels it.

Mom has done a good job of managing. She has hung on to the farm that Grandad, you and your brothers bought to start the family dairy. Not long ago, she sold the Kersey farm and built a lovely new home in Greeley. I'm happy she could do that. Mom deserves nice things.

Bob couldn't be with us that day at the hospital. Your surgery was like so many other family occasions and vacations—he had to stay home to milk the cows so the rest of us could be together.

After you died a lot of responsibility suddenly came crashing down on Bob's shoulders. He got married, took over the dairy farm and became a father all in less than a year.

Dad, if you had lived only a few months longer, you would have experienced the joy of loving, holding and knowing your first grandchild and only granddaughter, Stacey. She has grown to be a beauty and is now a sophomore at C.S.U.

Bob and Connie live in the house where you and Mom made your home and raised us kids. Besides Stacey, they have one son,

Clint, a sophomore at Greeley Central High School, your old alma mater. Connie teaches business classes there, too.

Lois and I both married the young men we were dating when you died. I'm glad you had the chance to know the men who became our husbands.

Lois and Jim now live in Sioux Falls, South Dakota. They have two sons, Brandon and Brock. Brandon is in the eighth grade and Brock is in the sixth. Jim is a research scientist and teaches in the medical school. Lois does clerical work.

No matter where they live, Jim promised Lois she would be able to come home every year to visit. He has faithfully kept his promise, and Lois and I have had the opportunity to strengthen our bond as sisters.

John and I got married about a year after you died. John has been good to me and I've tried to make him happy. We've had a good life. For many years John taught and was a high school principal. Now, he's a banker. Who would have ever thought your baby daughter would one day be a banker's wife?

I work for our area weekly newspaper. I really like my work and the people I work with.

Dad, my biggest regret is that my two sons, Maury and Mickey, never knew you. I'm proud of them, and you would be too. Maury is seventeen and Mickey is fifteen.

Recently, after the boys were in a serious auto accident, people said, "They must have had a guardian angel watching over and protecting them." I couldn't help wondering if that guardian angel was you.

Though it's been good to write this letter, because of my faith in a loving God, I believe everything I've written you somehow already knew.

I am grateful for your influence and guidance during the time we did have together. Sometimes I still feel you touching my life. Thanks.

Love,
Jan

❋ *Free...for a price* ❋

Free Donuts! Free Prizes! Free Coffee!
Hot Dogs! Balloons! Popcorn! Pop!
No purchase necessary!

Free is a magic word capable of drawing a crowd. Everybody loves a freebie!

Because I enjoy getting something for nothing, I frequent a candy shop in Colorado Springs. I stop in regularly. Every time I do, they offer me a free sample of their luscious chocolate mint truffles.

I don't buy much of their candy. I don't have to. The ample sample is delightful and adequate.

Eventually, however, there will be some special occasion worthy of an extravagance and I will buy some of the chocolates. When I do, I'll also be paying for all the free samples I've enjoyed.

In this world there's no free lunch. Yet, because we humans are a greedy lot, we continue to fall for this promotional ploy year after year as we write our planned activities on a free calendar with a free pen.

This something for nothing gimmick could even be utilized by churches. This Sunday, Easter Sunday, churches could host festive open houses. They could promote free breakfasts after free sunrise services where salvation is proclaimed a free gift from God.

Free?

Free to you and me, yes! But not without cost.

A great price was paid for this so called free gift. That price was the life and death of a sinless Christ.

There was no bargaining on the cost. No discount was offered. The price was paid in full.

❄ A hairy deal ❄

My mother was crying. She was sitting in the big chair by the picture window holding a mirror in one hand and tweezers in the other plucking her eyebrows.

I remember her telling me, "I've always admired Aunt Donna because she never plucked her eyebrows. Jan, your eyebrows are so nice and expressive. Don't ever pluck yours. Once you start, you can't ever stop. You'll have to keep it up the rest of your life."

❄ ❄ ❄ ❄ ❄ ❄

I was probably eleven or twelve-years-old when an older boy cousin decided to enlighten me.

We were sitting out on the lawn when he informed me I could look *so* much nicer if I shaved my hairy legs.

❄ ❄ ❄ ❄ ❄ ❄

In subtle and not so subtle ways, society has tried to mold me. Pressures come from all directions and feed on my insecurity–my feeling that somehow I'm not quite all right just as I am.

There seems to be an attempt to homogenize me so I will blend nicely with the entire population. Everyone as much alike as possible. A smooth and uniform mass of bland.

I wanted to look nice, or at least the very best I could, so when my cousin suggested I would be more socially appealing if I shaved my legs, the deed was done that very day.

I held the fort, however, and hadn't given in on plucking my eyebrows. I courageously swam the raging rapids upstream with perseverance. Until now, that is.

It's with a sense of bereavement I admit I gave in and plucked my eyebrows.

More times than I can recall a well-meaning beautician has informed me that allowing her to do my eyebrows would improve

my appearance. "It would lighten your face and open your eyes," I was told.

This sort of conversation has happened so often I began to believe I must either be blind or in the dark.

Over the years my mother's words of advice finally wore down. Societal pressure gained the upper hand. This time it was me with tweezers in hand.

As I stood in front of my bedroom mirror plucking out every wild hair, a steady stream of tears ran down my plump little cheeks.

Once I began I had to continue. It wouldn't do to have one beautifully arched brow that looked like everyone else's, and a shaggy one that looked like me.

If you haven't noticed the improvement, you're not alone. In fact, you'd be alone if you had. Not one single person has noticed or commented on my beautifully transformed brows.

I will admit when I look in the mirror I think my eyebrows look nice. Probably better. But who's to say what's better? Are we all just a bunch of dopes waiting to get duped?

As I gaze at my mirror I think to myself, "Well old gal, it looks like the plucky got plucked!"

❋ The good, the bad, and the ugly ❋

Almost as soon as Woolsey's Food Center opened, I was there picking up a few essential items before the full thrust of a snowstorm settled in. We were almost out of milk. It seems we're *always* almost out of milk!

As my groceries were checked out, the man waiting in line behind me said he had ventured out in the bad weather to buy a brownie mix for his young daughter.

"She felt like cooking something and she's got baking brownies down to an art," bragged the proud father.

"That's great," I replied. Then, patting my tummy, I added with a grin, "Well, maybe it's not so great?"

❋ ❋ ❋ ❋ ❋ ❋

A storm brings out a desire for me to transform my home into a bakery. The aroma of baking cinnamon rolls, chocolate chip cookies or hand-peeled homemade apple pie seems to provide comforting shelter from even the harshest blizzard that might be raging outside. That's the 'Good'.

The 'Bad'? Somebody has to eat it, and often that somebody is someone who really doesn't need it!

❋ ❋ ❋ ❋ ❋ ❋

I went home from the grocery store and, like the young brownie baker, turned on my oven. Before the day was over I'd baked two banana cream pies, three cakes and a batch of blueberry muffins. I fixed French bread pizzas for lunch and cooked a pot of beans and ham for supper.

During the baking times I boiled eggs, grated cheese and washed and prepared cauliflower, broccoli, green onions, carrots and a bell pepper to have in the refrigerator so anyone plagued with hunger could fix a quick chef's salad just by adding lettuce and ham.

When not in the kitchen, I washed a few loads of clothes and accomplished various other household chores. I even sat down and watched the afternoon matinee.

During the movie I ate a slice of banana cream pie. The indulgence made me feel guilty. I wasn't hungry. Without a snack, I wouldn't have died. My stomach wasn't even growling.

I kept asking myself, "If I *had* to eat, why hadn't I settled for a nice healthy chef's salad?"

With every bite of pie I thought about an earlier phone conversation.

John had called home around ten o'clock that morning (probably to see if I was up and out of bed yet). Proudly I reported on my projects in progress.

"My, you're a regular little...uh...What's the word?...Oh, what do you call someone who cooks a lot?" stammered my husband.

"Fat!" was my honest reply.

There you have it–how the 'Good' and the 'Bad' turns into the 'Ugly'!

❋ A gift too great ❋

"Boy, the preacher sure was fired up today," said one of my sons.

"Yeah, he really got going," agreed the other.

I had to confess, I hadn't noticed. Rather than listening to the sermon, I had been engrossed in my private world of introspection. My mind had been contemplating the events and circumstances of the serious auto accident that could have killed both of my sons, as well as two of their friends.

As my soul searching began, I recalled recently telling a friend, "I don't know what's wrong with me. Why can't I get over the boy's wreck? It's been six months now, but still I choose spending time alone taking care of me rather than being with people. I'm blah, have little motivation and initiate interactions with only a very few friends. Why can't I get my feelings resolved so I can get on with life?"

My friend had no answer.

On this Sunday as I sat in church, oblivious to the sermon, I prayed for one.

Reliving the night of the wreck, I was once again engulfed by memories of flashing lights illuminating the gnarled metal that had been my son's car.

Visions of blood, agony and tears haunted my memory. I saw my sons reaching out to me, seeking reassurance all would be well.

I had felt so helpless. I was painfully aware my touch, though comforting, was capable of changing nothing.

The investigating officer had clearly spelled out reality, saying, "These boys could be *dead.*"

Those direct and honest words forced me to focus on the fact that everything that lives will one day die. A long life, or even a life lasting to adulthood, is not guaranteed.

It's much easier to ignore the human condition. Mortality is inevitable.

The vitality and zest of my children could have been snuffed out in a single split second.

Then suddenly, in answer to my prayer, I gained a new perspective. I realized it wasn't the horror I was grappling with, but the goodness.

I had been given a gift–a wonderful, unmerited, undeserved, miraculous gift. My sons were spared. They live and laugh.

How does one fully realize, comprehend, and accept a gift so great as this?

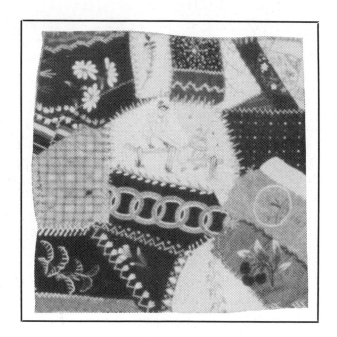

✻ All you have to do is ask ✻

After pushing herself to the limit, she realized her need and searched for assistance. Her request was simple –only one word, *"Help,"* uttered repeatedly and breathlessly soft.

It was a beautiful warm day for our area high school track meet.

To capture the emotion of the grueling race, I positioned myself near the finish line where the fatigue of the spent athletes would be most evident. It was there I heard that uttered request for help.

The runner was not disappointed.

After making her need known, she was quickly surrounded by support. Her teammates and coach knew she would be in need of help–and they were there.

✻ ✻ ✻ ✻ ✻ ✻

That weary runner's faint plea has echoed in my mind, causing me to remember various times when I've needed help. Sometimes I asked for assistance. Usually I didn't.

I particularly recalled the words a friend said to me at a luncheon I hosted.

I didn't know exactly how many ladies would attend this luncheon, so I guessed and went ahead and set the tables. After everyone arrived, I quickly took a head count and realized I needed two additional places.

After instructing my guests to serve themselves at the salad buffet, I frantically scurried off to my pantry to get everything I'd need to get everyone seated at my formally set tables.

That may sound simple; after all, the plates were already stacked by the food. But for this particular luncheon I had set each place at the tables with a knife, fork, salad fork, spoon, napkin, water glass filled with ice and lemon, as well as a goblet of bubbly sparkling juice complete with strawberry garnish, a chocolate candy and small bar of soap for a take-home favor.

A friend who was tuned in and aware of my desire for everything to be perfect followed me into my pantry. It was there our brief conversation took place. Her words were simple and appreciated. They also cut directly to the core of my independent personality.

"If you need help," she said, "all you have to do is ask."

There's a world of caring individuals out there–people who are willing, even eager to help.

I personally derive great pleasure from giving or assisting, consoling, lending a hand or adding a spark of fun to a special occasion or event.

Why, oh why, is it so difficult for me to let go of my independent nature, realize my need, and allow others similar satisfaction and joy?

Why is it so hard to ask for help?

❀ With my face to the breeze ❀

I'd like to say a beautiful picturesque creek with grassy banks and a flowery meadow ran alongside my childhood home, but it was really just an irrigation ditch.

Our house sat about fifty feet back from the ditch and irrigation water filled its steep banks every summer. My mother worried. She feared we might slip into the ditch and drown because the swift flowing water was deep.

In our front yard a row of huge shade trees grew with a lawn on one side and a steep dirt bank down to the ditch on the other. In the tree farthest from the house my dad fixed the best and most unusual swing in the whole world!

From a strong branch he suspended a single heavy rope. At the end of the rope he tied a gunny sack filled with more gunny sacks.

After climbing to the top of the bank with the rope in hand, we'd jump on this unusual swing and tightly wrap our legs around its gunny sack seat and hang on. With each long sweep out over the running water, with my face to the breeze, I was transported to my private world of fantasy.

My faithful friend, the swing, was always there when I was lonesome or to share my personal times of sorrow or joy.

When my grandfather, who lived next to us, had a heart attack, I sought the swing's consolation while waiting for the ambulance to arrive. I remained on my swing long after Grandad was wheeled out of his house. From there I saw the white sheet covering his face and knew he was gone.

At my birthday parties, after my friends sang, "Happy birthday dear Jan," I opened my presents. We ate ice cream and chocolate birthday cake, lovingly baked by my mother and piled high with sticky white fluffy frosting. Then, after playing the usual party games, we all went outside to swing on my very special swing.

❀ ❀ ❀ ❀ ❀ ❀

That swing, offering the total ecstasy of weightlessness at the height of each pendulum motion, is gone. In the name of progress, the bank has been filled in with dirt, and grass now grows to the very edge of the ditch.

Still clinging to pleasant memories of the hours spent on that swing, I keep a keen watch for a suitable substitute.

I find no transcending joy aboard modern playground swings. The rubber strap that's suspended between two chains may be safe and fine for children, but literally inflicts adults with an excruciating pinching pain.

This summer I located a plain old board seat swing.

Several times I've hopped aboard this swing and, with my face to the breeze, searched for the lost bliss of my childhood.

While pumping this swing so high its metal supports began to slightly sway, I experienced a strange new feeling. Rather than recapturing a sense of weightless delight, releasing me from the weighty adult world of responsibility and worry, at the height of each pendulum motion I felt an unmistakable wave of nausea.

Weightless ecstasy must be a very special state reserved only for children.

❋ Starting and stopping ❋

I opened the refrigerator and peered between bottles of mustard, maraschino cherries, relish, chocolate syrup, soy sauce, milk and left over tossed salad. I was in hot pursuit of some savory tidbit or morsel. I saw hot dogs and cheese in the refrigerator compartment and ice cream in the freezer.

Finding nothing that immediately appealed, with a swift and single motion I turned and closed the refrigerator door. Viewing my cupboards, which were only a few steps in front of me, I headed toward the one where delights such as miniature marshmallows, chocolate chips, coconut, raisins and pecans were stashed. Because none of the packages were already opened, I quickly closed the cupboard door.

Looking down, I spotted the drawer where bags of potato chips, cheese curls, cookies, bread, corn chips and pretzels were stored. Quickly I reached for the open bag of corn chips and peered inside. I found crumbs.

My scavenge then led to the lazy Susan. As I gave it a spin I saw honey, maple syrup and peanut butter rotating before my eyes. Likewise, I rotated toward the pantry where I found potatoes, onions, mandarin oranges, sardines, taco sauce and green beans.

I wasn't sure exactly what I was hungry for. Only that I hadn't found it.

Contemplating my options, I first popped several maraschino cherries in my mouth. Then I put a hot dog in the microwave, opened a can of sardines, and spread mustard, crunchy cheese curls and relish on a slice of bread. When I put everything all together, I had myself quite a tasty sandwich.

When the sandwich was gone, I realized my appetite hadn't been appeased so I considered my next move. Ice cream seemed a good primary ingredient. I heaped a bowl full then topped it with maple syrup, chocolate syrup, mandarin oranges, coconut, pecans and crushed potato chips. Alas, I had created a sundae of unique texture and taste.

Since everything had failed to hit the spot, I grabbed the peanut

butter, a slice of bread, and a banana that happened to be innocently sitting on my counter. After spreading a thick layer of extra chunky peanut butter on the bread and adding some sliced banana, I eyed my work of art. Something seemed missing. It wasn't complete. After due consideration, I added miniature marshmallows, honey and chocolate chips.

Though proud of my culinary creations, my craving remained. I tried cookies dunked in milk. Green beans seasoned with onion, raisins and soy sauce followed, as did pretzels topped with taco sauce and melted cheese.

I had literally wiped out the groceries.

After I had taken inventory, tossed salad, potatoes and an empty, unfulfilled feeling deep in my gut was all that remained.

I had not been appeased.

My craving was still unsatisfied.

Then began the soul searching.

Instead of food, what was I really hungry for?

Someone to talk to?

A bubble bath?

Fresh air?

Exercise?

Sleep?

Fun?

Certainly not food!

And that's when I realized it's very difficult to stop eating if you aren't hungry for food when you start.

❉ The ups and downs of life ❉

The needle on my sewing machine was going up and down through the fabric with speed and precision. The stitches were smooth and even.

Then, as I stepped down even harder on the foot pedal, the needle suddenly stopped. Looking closer, I discovered the stitches had become uneven, resulting in little loops of excess thread.

I tried to remove the fabric, but couldn't. The needle wouldn't budge. After tugging on the wheel, one way and then the other, I finally raised the needle enough to free the fabric.

When I turned the fabric over to inspect the underside of the stitches, I discovered a large knarled mess.

It reminded me of life.

A busy schedule with lots of activity keeps me operating at my best potential. Yet, there's a fine balance that can be difficult to maintain.

A proper tension is required. With too little stimulation I procrastinate and accomplish little or nothing. When too much is required or expected, my stomach aches and I get grumpy and tend to fall apart at the seams.

Tension can be good. If I invite company for dinner, I feel positive tension that helps me accomplish a great deal as I make my preparations. A day I might have idled away is suddenly filled with meaning and purpose.

If, however, I invite company for dinner on a day that's already too hectic, I become overly stretched. My smooth tension becomes tense and tight. Stress results and ultimately sends its poison surging through my system.

When I was a child, my mother encouraged me to learn to sew. However, she also regularly warned me not to mess with the sewing machine's tension. If it got out of whack and off kilter, she said it would be tedious and time consuming to properly regulate and get back in sync.

Just like a sewing machine, I must learn to carefully set the tension in my life. It takes time to discover a smooth and even balance which maintains an inner fiber strong enough to endure life's unplanned stresses without becoming raveled.

❋ Desires and dividends ❋

Right now, at this very moment, what would please you? Isn't there something you crave or have a hankering for? Don't you have some deep seated longing or maybe just a spur of the moment impulse you'd like to realize?

They say, "The difference between men and boys is the price of their toys." If that's true, what extravagance would you like to have to amuse yourself?

Maybe you'd enjoy a raise so you could buy that special toy. Or would you like time off so that toy, once obtained, could be played with more often. While being debt free could be the desire of some, others might seek financial security.

Me? I'd like ice cream, chocolate, and a clean house–and while I'm being narcissistic and indulging myself in fantasy, why not throw in a gorgeous body, prettier face, smaller feet, natural curly hair, legs that never need shaved, or even just a minute of restful peace and quiet at the end of a particularly long and harried day?

If you've been playing along in this dream game, I'm sure, between your list and mine, we've come up with some pretty incredible desires. This flight of fancy nose dives and bombs, however, upon the realization most of these delightful whims are flimsy and fleeting. Their realization wouldn't quench thirst or satisfy hunger in any real or sustaining way.

According to psychologists, people seek solid, long-lasting relationships. Our common longing is to have someone to laugh with, cry with or simply sit and do nothing with. It would be a rare privilege to trust someone enough that you'd be able to let your hair down and risk revealing that deep-down and dark-inside part of yourself you usually try so hard to hide; and through it all, be confident of understanding.

This need to be understood is deeply ingrained in the very essence of my being. Once when I was expressing this to my friend Julie, she responded, saying, "You sound just like *Anne of Green Gables*. Anne was always searching for and talking about 'kindred spirits'.

I'd never heard of *Anne of Green Gables* nor the term 'kindred

spirit', but Julie had aroused my interest and I wanted to know more. I learned *Anne of Green Gables was* the name of the first in a series of six books written by Lucy Maud Montgomery. Though published in 1908, between the time when I was an adolescent and the present, this series grew in popularity and has become classic literature for young readers.

Just as soon as Julie told me of this precocious 'kindred spirits' seeking Anne character, I had a copy of the book in hand. I fell in love with Anne. My devotion drove me to obtain the video. Soon after that I ran across the complete six-volume paperback series of books about Anne and her adventures. *Anne of Green Gables* quickly worked her way into my heart by becoming a bosom friend and 'kindred spirit'. The books are now a treasured part of my home library.

In the course of writing this weekly column, I try to laugh with, cry with, or simply sit and do nothing with my readers. At times I have exposed as much of me as I can bear to bare. I trust that somewhere out there are readers who understand this person that my writing reveals.

Frequently people I know and see around the area comment on the things I write. From time to time readers I don't know take time to write a letter in response to a particular column. Occasionally I've even been afforded the opportunity to meet some of my mysterious and unknown pen pals, thereby putting a face with their name.

Recently, while in Colorado Springs for an early morning doctor appointment, I saw the profile of a man enjoying breakfast with his son. Suddenly I realized maybe I knew the man. I thought he looked like Hank, a Colorado Springs reader, who from time to time has corresponded.

As I studied the distant profile, I wished he would turn his head so I could be sure. Even though the man didn't look my way, I decided to risk making a fool of myself and approach this person who could turn out to be a stranger.

After taking a deep breath, I took my first step. It was a risk that

paid an incredible dividend.

"Hank?" was all I timidly said when I reached the table where this man and his son were seated.

It was all I had to say.

Once the man looked at me, my single word question was answered by an expression of recognition spreading across his face. It was in fact Hank, and his response made it a very pleasant encounter.

I can't recall everything Hank said that morning but, I'll *never* forget that he said, "When I read the things you write, I feel like I've found a 'kindred spirit'."

Because of my own personal ongoing search for 'kindred spirits', nothing else he might have said could have pleased me more.

❉ Autumn leaves ❉

The distant horizon greets me as I walk through a landscape painted with the rich warm tones of gold, bronze and crimson. The gentle autumn breeze, even on a sunny day, possesses an unmistakable chill.

Overhead, the leaves clinging desperately to barren branches, rustle a melody of greeting as I pass. With an accompanying percussion rhythm, the brittle fallen leaves scrunch into countless dried bits as they cushion my steps.

I like the gentle, warm and sunny autumn days known as Indian Summer. The out-of-doors beckons. I long to take respite from the busyness of day-to-day routine to recreate my being.

My lungs expand with exhilarating fresh brisk air. The stress, worry and frets of the day are exhaled, releasing me from their exhausting drain on my energy.

Hidden in the grass out under a big willow tree I spot a cottontail. With lop-ears tucked down close to his body, he blends in with the natural terrain. Except for his large, acutely perceptive and frightened eyes, I might not see him.

Once I'm past, the furry animal relaxes his tense muscles and hops off in the opposite direction.

High overhead in a large oak tree a pair of squirrels bicker at one another. I smile and think, "Those two must be married."

The red robin is gone, but a V-formation of high-flying geese honk their way across a clear azure sky. Their migration south is a predictable sight of the season.

Autumn can appear a dreaded drab time, focusing on death, dying and the stark reality of the severe elements. The wildflower blossoms lose their bright blush and wild grasses are no longer green. Their apparent life force has been snuffed out by a freezing blast from the north wind.

Survival of the fittest is the governing rule of nature. Through the long cold winter, the old or weakened animals will succumb, falling victim to harsh decree.

At the appointed season, the quiet darkness of death is natural. Even welcome.

Just as day follows night, spring will follow a winter of rest. Seasons turn into years. Years accumulate into lifetimes. The future will belong to the progeny.

Geese will make a return flight when winter is past. The blades of grass will sprout and flowers will bloom and grow anew. When the robin returns, a nest will be built high in a tree, barely visible, hidden amidst the strong branches and a fresh growth of lush green leaves. In the spring, prolific signs of new life will be witnessed throughout the realm of nature.

But today, as I walk through a landscape painted with the rich warm tones of gold, bronze and crimson autumn leaves, I feel a cold wind that follows the setting of the sun. The wind whisks past and stings my unprotected cheeks.

Wishing I could retreat to a sanctuary of immunity, I am reminded of the revitalizing necessity of a time to rest.

❋ Fumble fingers ❋

Every muscle movement of each pro playing in Super Bowl XXII will be scrutinized and magnified, almost as if the game were under the surveillance of a mega-intense electron microscope.

The Denver Broncos and the Washington Redskins will be center stage producing exciting drama, while fans across the country hope to applaud the outcome with a rousing ovation of praise for their favorite team.

Even if asked, I wouldn't want to be a Denver Bronco. When I play center stage with the ball coming right at me, my persona is immediately transformed from a confident contemporary into a fumble fingered frump.

Desiring to make a good impression, I prepared and practiced my game plan, which consisted of getting out the area telephone book to discover and memorize the first name of our future guest.

I was so proud and confident. *I knew* I had his name available for immediate on-command recall.

After the basketball game, I walked on stage and opened myself up to impression assessment when I began meeting arriving guests at our door. I proudly greeted this particular gentleman by name and told him how good it was to meet him. Simultaneously, my husband John looked at me in horror.

As I scurried off to complete preparations in the kitchen, John followed me. It seemed we disagreed on the first name of our guest.

Even though I *knew* I was right, I checked it out and discovered I wasn't. John was. I had memorized the name of our guest's brother.

Oh, the embarrassing agony of defeat and humiliation of apology, especially following focused diligent effort and practice. I would have been better off waiting for an introduction rather than preparing this resulting offense.

The evening proceeded, proving to be even more memorable.

After all the guests had food and beverage, I filled my plate and joined them in the living room.

Knowing myself to be messy, I voiced my need to return to the kitchen for a napkin or two, just in case.

Finally, with napkins in hand, I sat down and eyed my barbecued beef sandwich to determine the best plan of attack. With all the eyes in the room focused on me, I took a bite of sandwich as a dill pickle rolled off my plate and onto the floor.

The lady sitting next to me smiled and politely said, "You dropped something."

I tended my injured pride while she retrieved the fallen pickle, returning it to my plate.

Forcing a smile, I proceeded to eat the pickle. I wanted it out of sight and gone.

Because everyone seemed to be watching me chew, I explained my action, saying, "It's OK. We don't have a dog."

There's no doubt about my reaction to attention. When faced with pressure to decide whether to punt, pass or kick–I choke!

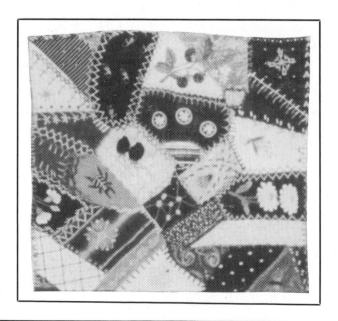

❉ Sorry you asked? ❉

"**A**nd how are you doing?" is a question many concerned friends have asked since my son had mononucleosis, my father-in-law had a heart attack, and both wound up hospitalized.

"Just fine," had been my pat reply–at least until one fateful day last week when nothing went right.

From beginning to end I had a terrible, horrible, no good, very bad day, just like Alexander experienced in a book by Judith Viorst which I enjoyed reading to my sons when they were young. All my buried emotions erupted, and one of *those* days was the result.

I mopped the floor and immediately it was attacked with mud. While vacuuming the carpet, the dirt bag got ripped on a clay flower pot, causing a dust storm. I poured bleach into an almost empty liquid detergent bottle so I could prudently get every last drop of cleaning power. When I shook the mixture, the plastic container exploded.

No matter what I did, I created mess rather than accomplishing clean-up.

At one point I got down on my hands and knees and hysterically beat my fists on the floor, a recommended technique to vent frustration and anger. It was effective. I forgot everything else until my fists quit stinging.

I gave up on baking a pie. After I had rolled out the pastry, it totally fell apart while I attempted to transfer it to the pie pan. In revenge, I threw the dough in the sink and down the garbage disposal.

I sat down at the height of this abominable day with a glass of freshly brewed iced tea. While sporadically sipping, I was jolted by an excruciating pain in my mouth. While exploring with my tongue I realized a tiny chip of ice had lodged in the variegated biting surface of a particularly sensitive tooth. Before my tongue could budge the ice, it had melted, but pulsations of pain lingered.

My pause to refresh hadn't been the oasis of relaxation I had envisioned and desired, but did provide enough relief to allow me to continue my day.

With errands to run, I decided to get myself publicly presentable. Before applying make up, I smeared tooth paste on my tooth brush so I could brighten my smile. While opening my mouth wide enough to expose my absence-of-wisdom teeth, I noticed a dark line on the tooth that had just suffered an ice attack. As I gently prodded with my finger, the outside enameled surface of the tooth broke away, exposing the underlying dark gray filling.

Immediately I called the dentist and made an appointment.

Now I'm looking forward to another terrible, horrible, no good, very bad day.

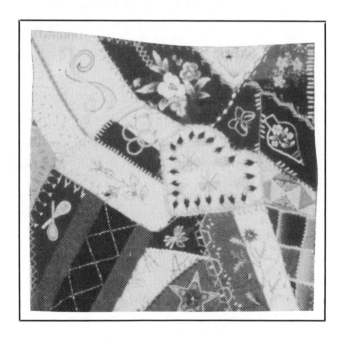

✸ The "Hi" ways & "Bye" ways ✸

et out a map.
It doesn't matter if it's for a
town, city, county, state or country.
Take a good look at it.
What do you see?

On any one of them, I see a scaled-down depiction of a network of ways, usually called roads, to get from here to there. These roads typically go somewhere. Other times they go nowhere and dead-end.

If you travel from Colorado Springs east toward Ranchland territory, Highway 24 and Highway 94 go a little way together. United. But before long they separate. Each headed east, yet toward its own destination.

While traveling, others using the roadway will be going in the opposite direction, west. Every meeting requires faith–faith the other traveler is physically competent to remain on the other side of the road, and faith the other vehicle is in safe operating condition.

Along the way are crossings where roads meet or intersect. Because these side roads are less traveled, stop signs are posted at intersections, yielding the right-of-way to those traveling on the busier thoroughfare.

These side road stopping places require every traveler to pause and look to see if the way is clear. A decision must be made whether to continue on and cross the highway or turn and begin a new direction.

Sometimes the stop signs are overlooked or ignored. A loud and damaging confrontation can be the result of this collision course. Although this occurrence is rare, all are aware of the inherent risk and possibility of lingering pain or disability.

One could decide to become an isolated hermit, never exploring for fear of hazard. But the opportunity to discover and experience is exciting. It keeps most of us willing to venture out from solitary isolation.

Roads were built because people need the goods or services offered by other people. This entire area was once desolate. Now

an extensive network of paths and ways is available to bring people closer together.

We're all travelers and our small segment of the world can serve as a microcosm of human interactions. Some travel in opposite or crosswise directions with increased risk of confrontation, while others stop, yield and share their journey for a distance.

If we decide to share our journey, the only effort necessary is to greet others we meet along the way with a warm smile and a cordial "Hi." People then develop acquaintances and alliances of friendship. Some may even get married. These united and interacting lives become intertwined through mutual sharing. Together they experience times of joy, sorrow, laughter and tears.

But there is risk. These "Hi" ways may become "Bye" ways.

Sometimes these unions of the heart dissipate over time or distance. Others dissolve by mutual consent, betrayal or death. Be advised that there may come a time to say "Bye" and part company, each continuing on, in separate directions. But to risk *nothing,* is to risk *everything.*

�֎ *Halloween horrors* ✖

Ghouls, goblins, ghosts and other mysterious and ghastly creatures haunting through the night, causing fright, aren't the only horrors of Halloween. Witches are known to search for rodents, spiders and bats as a base for boiling up a brew. Other times, substitute ingredients are readily available to prepare a totally fresh fiendish feast.

Green slime, melon mold, curdled cream, and crusted blood could be combined into a pungently fragrant and bubbly broth. For added convenience, a trip to the grocery store isn't even necessary. Just clean out the deep dark moist and murky recesses of the refrigerator.

Although a wonderful modern convenience, refrigerators can become caverns of crud.

Some people store leftovers in semi-clear plastic containers that allow the contents to be semi-visible. I prefer the no-extra-expense storage provided by emptied blue, green or yellow margarine tubs. With them, the contents remain hidden from view and match the blue, green or yellow mold that eventually begins growing inside.

Recently I had a hankering for a nice crisp tossed salad. Because the washed lettuce was turning red with rust, I pulled out my refrigerator's vegetable drawer where I try to keep a fresh extra head. The plastic-wrapped lettuce had crisped in the crisper so long, wilty green slime oozed, dripping through my fingers when I picked it up. I opted to round out that meal by opening a can of peaches.

I think cantaloupe are wonderful. So wonderful, I bought them in greater quantity than we could possibly gluttonously gorge ourselves on. A couple of mushy moldy melons still remain. Nobody else will touch them, so it's up to me to dispose of them.

Homemade ice cream is a favorite dessert. Sometimes we crush some chocolate cream-filled cookies into a mixture of cream, eggs, sugar and milk to make cookies 'n cream ice cream. Other times, the cream has been in the refrigerator so long it's soured and turned into curds and whey. Those times, we settle for cookies and skip the cream.

I try to remember to get meat out of my freezer in advance so it has time to defrost in the refrigerator. Sometimes the thawed meat bleeds and runs all over. On occasion, blood has even managed to drip and dry in a crusty pool. Yuck! Dried blood either requires soaking or a chisel and hammer to remove.

Halloween night seems an appropriate time to get my big black caldron out of the cellar. After I rid the fridge of tainted unrecognizable rot, I'll add a few of the spiders and webs collected while washing windows and stir up a simmering stew.

Dinner anyone?

Reservations required.

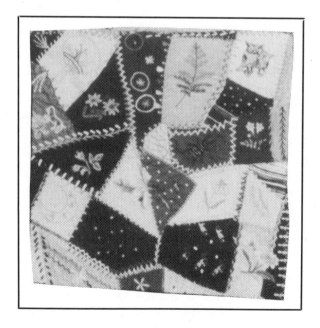

❧ In good light ❧

We all strive to look our best. Because the beauty industry knows this, special make-up mirrors are marketed to assist. These grooming aids have settings to simulate various environments. Typical office, daylight or evening light can be the mirror's selected illumination. Make-up can then be appropriately applied, according to where and when you're going to be publicly seen.

The marketing genius who was inspired to develop this nifty grooming aid knew none of us want to be seen in bad light.

Vanity dictates that when we go out in public, we should create a myth and try to look good. Men shave, comb their hair, change clothes, splash on some cologne and suck in their gut. Women do their hair, apply lipstick and blush, pluck a straying eyebrow, coordinate an outfit and wiggle into pantyhose. All people have their own individual routine, designed to improve or enhance appearance.

Unexpected visitors can create tension if, instead of concentrating on conversation, the focus becomes the rumpled newspapers, tossed couch pillows, strewn afghan and scattered dirty dishes.

When the door is opened to expected guests, a squeaky clean environment allows everyone to relax.

❀ ❀ ❀ ❀ ❀ ❀

My doorbell rang.

I had been caught lingering, enjoying the cozy warmth of my blue down comforter before getting up and out of bed. My hair was unruly and sticking out in crazy directions. I hadn't even washed the sleep from my eyes. Rather than rising and shining, I turned over and covered my head with a pillow.

The person at my door would have to go away. I was not ready to face the world.

Then, though muffled, I heard the doorbell ring again. Whoever was at the door, had not gone away.

After dragging myself out of bed, I walked down the hall to a window where I could see who stood at the door ringing my bell.

Recognizing the unexpected visitor, I hurried back to my bedroom, pausing only to throw on a robe before answering the door.

This encounter could have been uncomfortable if I had focused my attention on the surrounding living room clutter or become inhibited by my appearance. But because my visitor was a *friend,* I was at ease.

In the presence of a friend one can risk exposure in ordinary light, totally unadorned.

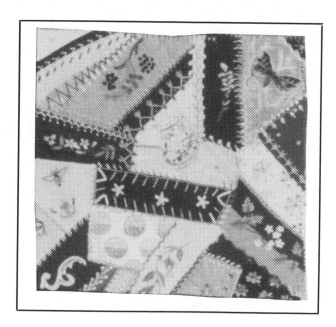

❋ *Accounting for time* ❋

At the end of every December I sit down at my kitchen table with my nearly obsolete, smudged and filled calendar and a clean, blank new one. One provides an accounting of time past, while on the other I will program the future.

Very methodically I go through the months, beginning with January, transferring the various birthdays, anniversaries and occasions I'll want to remember in the coming new year. During this process I can't help noticing what a hectic life I lead. Busyness seems synonymous with contemporary society.

A calendar gives a good overview of a spent year, indicating my state of health and how well I brushed and flossed by the number of doctor and dentist appointments. By reviewing the calendar's full and grimy pages I can give an accurate listing of all our activities, as well as how seldom we were all home to eat an evening meal together.

With a quick glance, it's easy to see that throughout a year very few of those little two inch by two inch blocks of time remain blank. Most are filled with places to go and times to arrive.

With a longer study, I become painfully aware of how little time was set aside for important things like interactions with family and friends.

The calendar represents a year. Each page stands for a month. Every square is one day's twenty-four hour allowance of time. Somehow, every night at midnight, I am miraculously sucked from one little box into the next, to make of it what I will.

One day, maybe this year, maybe another year, I will enter one of those little boxes and not find a way out. My life will be over and it will be my survivors who ultimately review my life and how I spent it to determine if there was meaning, purpose or value.

When people ask what I want for Christmas, the best answer might be, a brand new year. I couldn't receive anything of greater value.

❧ The dawning of a new age ❧

Even though the four-year-old girl had a faint smile on her face, most noticeable to me were her eyes. As the young, innocent, sensitive and faintly sad eyes looked back at me, they seemed to probe.

I looked at the picture closely because it was of me. It appeared in a birthday greeting ad placed in *Ranchland News* by a conspiracy between my sister, a friend and my husband. The ad had a big, bold, attention getting heading: "Lordy, Lordy, Look Who's Forty."

"That's not the picture I would have picked!" was my reaction when I saw the ad.

"Why?" asked my husband. "What picture would you have picked?"

After retrieving a family album, I pointed at a picture taken of me in infancy and said, "This one!"

"But nobody would have known it was you," my husband responded.

"I know!" I retorted. "That's *why I* would have picked it!"

❈ ❈ ❈ ❈ ❈ ❈

Now that I'm forty and have probably lived over half of my life, I took a long hard look at the picture others picked to publish in my birthday greeting and wondered, "What kind of person did this little girl become?"

One friend told me, "Now that I understand you, you're so different."

"What do you mean?" I asked.

"Well, you're really a much warmer person than you allow most people to know."

Another just plainly stated, "Two or three years ago, I couldn't have had you for my friend."

"Why not?" I questioned.

"I wouldn't have been ready or able to cope with all the questions you ask," she replied

I responded saying, "I hope you know you don't ever have to answer my questions just because I ask them."

"Oh, I know I don't," she assured. "But, your questions are good for me. They force me to deal with the issues I try to avoid."

It's reality. Everyone *wouldn't* want me for a friend. Yet, this birthday has brought overwhelming evidence there are many who do value me.

❀ ❀ ❀ ❀ ❀ ❀

Feeling old and blue, a few days before my birthday, I went down to the Town Hall to renew my driver's license. The reality of turning forty suddenly hit and before the day was over I headed off to Denver after a beautiful dress I saw a month earlier and liked but didn't buy.

When I got to the store, the dress was gone. In desperation, I found another. Contented and pacified, I headed home.

When I arrived, I was greeted by my husband, his parents, and my son Mickey, who insisted I model my purchase.

"I like it," said my husband.

"The color is pretty," said his mom

"It fits you real nice," added his dad.

"How much did it cost?" asked Mickey.

After ignoring my son, I focused on the compliments. Positive fortification gives *any* day a lift. But, the best was yet to come.

Before long, John's parents gave me a surprise box. Inside were forty individually wrapped birthday presents. I felt just like a *young* kid on Christmas morning.

The next day mysterious birthday cards started arriving in the mail. Many were from friends I hadn't seen since I married and moved away from Greeley. Later I learned my mother and sister had initiated this shower of cards.

Some of the cards poked fun: *It could be worse. You could be pregnant!* Others offered advise: *Don't go to work today. Call in old!* Or wisdom: *Being forty is a wonderful thing!... To someone eighty.*

For over a week the cards and celebrating continued. I had a chance to wear my new dress to a party, enjoyed lunch with friends, was treated to a birthday cake at work and surprised by my husband and a couple of scheming friends with an unexpected party,

complete with balloons and chocolate cake.

On my birthday a large package from my mother arrived in the mail. Quickly, I grabbed a butcher knife from the kitchen drawer and cut the top. When I opened the box and looked inside, I was speechless. Tears welled up in my eyes as I gazed at the beautiful hand painted porcelain doll.

As I tightly held and hugged the lovely, fair and fine-featured doll, my mind raced back to a Christmas past. I realized this was the *perfect* gift for my mother to give me on my fortieth birthday. Once again I could hear her saying, "This Christmas was kind of hard. It's the first year I didn't buy a doll. I have to accept the fact my girls are growing up."

❀ ❀ ❀ ❀ ❀ ❀

I've concluded turning forty isn't so bad. On my birthday I stayed up past midnight reflecting on my past and relating to the Jimmy Stewart classic holiday movie, *It's A Wonderful Life.*

I'm no longer apprehensive about the second half of my life. There are benefits.

I will be able to view circumstances that come my way through the perspective obtained through forty years of experiences. I now see, enjoy and appreciate subtleties, textures, colors and flavors that I previously might have missed or ignored.

I've had time to learn about myself and can no longer fool myself. Not easily anyway. I know when I'm making excuses and when I'm making choices–and the difference between the two.

I've quit looking into my mind expecting brilliance or my mirror expecting perfection. Even though it's nice to receive reinforcement or approval from others, I know the most important person to please is myself–and I've learned to value my opinion.

❀ ❀ ❀ ❀ ❀ ❀

I was up early the day after my birthday. I didn't want to miss the dawning of the second half of my life.

❋ Letting go ❋

Hours and hours of my time went into selecting and making the gift. The colors, chosen with care, were intended to accentuate personality or enhance decor.

Once the various elements were collected and cut, they were combined and assembled with careful attention to detail.

It didn't matter whether stapled, soldered or sewn together. By the time given, I had invested and bound much of myself into its creation.

During construction, I fantasized about the recipient's pleasure and happiness upon receiving my labor of effort and love. I envisioned where it should be displayed or how it would enhance attractive features when worn.

After hours, days or maybe even months of attention, I painstakingly placed the finished object in an appropriate box and concealed it with festive holiday wrap and ribbon.

❋ ❋ ❋ ❋ ❋ ❋

Christmas is over. The new year has arrived.

The wrapping paper that was eagerly ripped and carelessly tossed aside has already been hauled away by the trash man. Christmas decorations have been packed and the tree taken down. Things are back to normal. Now, if only I could rid my body of its annual desire for holiday goodies and start craving carrots, lettuce and celery instead!

While I get my mind off of peanut brittle, fruit cake and fudge, I also have to let go of the gifts I've given.

❋ ❋ ❋ ❋ ❋ ❋

I visited the recipient of a token of my affection. The purpose was to enjoy each other's company, but I also kept a keen lookout for the given gift. I was eager to see if it looked as tasteful and nice as I'd anticipated.

In my mind it *should* have been hanging near the kitchen sink where it would frequently bring me, the creator, to mind. But, upon entering the kitchen and glancing at the window, I could see it *wasn't* there.

During our time together, we went into the living room and looked at an album of holiday pictures. I tried to view them with genuine interest, but my eyes kept darting around the room, hunting in every nook and cranny for my creation.

When the clothes dryer buzzed, we went to attend to the load of permanent press. Passing the bedroom and entering the laundry room, I couldn't catch even a glimmer of the gift I had given.

In desperation, I excused myself and went into the bathroom. I didn't really need to use the facility. Instead I cased the joint like a rookie detective to see if this might be where the object of so much of my time and talent was on display.

Before leaving I resigned myself to the obvious conclusion. The gift I had given with incredible intention to please, had not been receptively received.

Though long past, that Christmas vividly lives on in my memory.

I had desperately desired to delight and selfishly sought increased endearment. I wanted my gift to be the best and most meaningful of all received. My greed ultimately subdued and destroyed all the pleasure.

I should have learned a gift really given, has *no* strings attached.

I enjoy giving tangible tokens of affection. Though I rationally know the given gift is no longer mine, it can be difficult to let go and cut loose the strings of emotional attachment with no expectation of appreciation.

Gifts can't be freely received if they aren't freely given.

❋ Jellybean ❋

"Hey, you look like a jellybean–a bright red jellybean!" quipped a teenage friend, referring to the shiny, bright red coat I was wearing.

"Don't you like it?" I asked, allowing my insecurity to surface.

"Yeah!" he replied. Then after a big grin spread across his face, he added, "If the fire alarm sounds, you're all ready to go!"

I like my jellybean coat. When I first saw it, I was reminded of a cinnamon candy apple. Not only is the coat a vibrant and shiny color, but I got it for an incredibly low, low price. I was so proud of my lucky find it never occurred to me that maybe the price was so cheap because nobody else would buy it.

Though I've owned my self-indulgent bright red coat for over a year, my husband hasn't said too much about it. That's not true of my sons. My youngest son, seventeen-year-old Mickey, is particularly vocal. "Oh Mom, you're not really going to wear that coat to church, are you?" he asks with a pleading voice.

I've walked out the door wearing my jellybean coat countless times. I like my red coat because it makes me feel totally alive, bursting with energy and noticed. Lots of people look at me every time I wear it!

Maybe all the attention is due to the associated psychological and emotional implications connected with red.

Red can mean communist.

Red could describe the facial tone caused by embarrassment.

The calendar's red-lettered days are celebrated holidays.

When desiring to greet important visitors with courteous hospitality, people roll out a red carpet.

Even though red lights can be annoying traffic-stoppers, it's the red-light districts that are to blame for giving red a sinful and immoral connotation.

I happen to like the color red.

Not only do I wear a red jellybean coat, but I wear red earrings, red necklaces, red shoes and frequently carry a red purse. I also own red sweaters, blouses and knit tops as well as a red dress. Because

I've always liked red, it's a color I wear even after Christmas and Valentine's Day are past.

I consider red slacks basic to my wardrobe, and I can't remember a time when I didn't own at least one pair.

After recently buying a new pair of red slacks to replace my old faded red pair, I've been forced to reassess my thinking.

This reappraisal is due to the reaction of a friend who, after learning of my purchase, with a tone of astonishment commented, "*I* wouldn't own red slacks!"

"Why wouldn't you wear red slacks?" I incredulously asked.

"I'd feel so...so conspicuous," she replied.

Since that conversation, I've been taking my own confidential survey and asking anyone and everyone, "Do you own red slacks?"

The results are in and I've become aware red is a very controversial color. Women either wouldn't think of wearing red, or wear red and think nothing of it.

My final decision about personally wearing red shall remain confidential, though obvious and noticeable!

❧ New beginnings ❧

Stacey and Paul stood together at the altar. Before God they joined hands and hearts, eager to make their new beginning. The union of these two young people signaled a significant family milestone. Stacey, my niece, is the first among her generation of family offspring to marry.

It's been almost twenty-two years since I, the baby of the family, got married. Because my father had died, I was given away at my wedding by my brother, Bob.

On this day, as Bob gave away his daughter, I cried.

I also remembered...

❅ ❅ ❅ ❅ ❅ ❅

All the days of my parent's lives, though more numerous than some folks are allowed, were not enough to enable them to rejoice together at the marriage of any of their three children.

Dad died November 9, 1966.

Mom experienced widowhood in the autumn following my graduation from high school. For all of us, but especially for her, it meant bravely looking ahead and making a new beginning.

Before 1968 arrived, my brother, my sister and I had all married and left home.

I recalled a guest at my wedding reception bluntly asking, "How can you get married and leave your mother all alone? It's hardly been a year since your father died!"

Nobody needed to tell *me* that! I was well aware of when my father had died. The question was a cruel and unfair wedding day guilt trip to lay on any bride!

Mom didn't want me to miss out on my life. Nevertheless, suddenly being all by herself must have been overwhelming.

More than once I heard Mom say, "The worst thing about being a widow is going home. It's so hard to walk into an empty house."

John and I visited Mom a couple of times a month during the first few years we were married. Because of those frequent trips to

Greeley, we saw Mom make the transition from a grieving widow to a woman waiting with excited anticipation for her suitor's next phone call or visit.

Meanwhile, I experienced a weird role reversal. I became Mom's parent. If she went out on a date, *I* anxiously sat up waiting for *her* to get in.

One particularly late night, I remember asking John, "What do you suppose people their age do when they go out on a date?"

Eventually, Mom determined Robert to be the new love for the rest of her life.

When Mom married Robert, *her* children gathered in a small chapel glowing with brightly colored light filtering through stained glass windows. It was *her* children who stood in attendance as Mom and Robert gave themselves to each other.

I'm not sure my brother, sister or I realized it at the time, but as Mom and Robert professed their mutual desire to make a new and common beginning, we were much more than mere witnesses. Simultaneously, we, *her* children, mystically became *their* children.

As I bravely ventured into this new world of expanded family and extended relationships, it didn't take long to learn that loving Robert didn't betray or diminish the love I'll always feel for my father.

My children never knew their natural grandfather.

Robert is Grandpa.

❁ ❁ ❁ ❁ ❁ ❁

"It takes daring to give to each other all that they have and all that they are," said the priest officiating at Stacey's wedding.

Yet, this ambiguous *everything* was what Stacey and Paul vowed as they promised to love each other for better or worse, for richer or poorer, in sickness and in health.

Pointing out that hardships and difficulties are inevitable, the priest continued, saying, "In spite of the fact no life is always good, because of love, Paul and Stacey are eager."

There was happiness throughout this wedding celebration. Laughter was heard and tears of joy shed.

Stacey believes Paul to be the greatest person in the world. Paul

knows Stacey is. Their entire existence is encompassed in total loving passion for each other.

"I will love you and be true to you all the days of my life," was the promise Stacey and Paul made to each other without hesitancy or reservation.

I watched as Grandpa courageously danced to up-tempo rock 'n' roll music with his beautiful granddaughter at her wedding reception.

Somehow, the sight of this cross-generation duo, brought together by harsh circumstance and the evolution of life itself, was a testimony to the mystical essence of the marriage union.

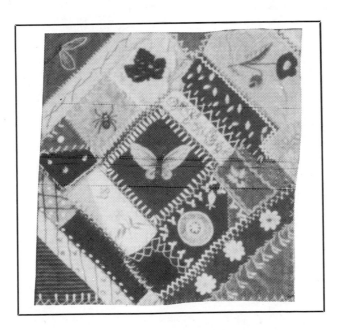

❊ Restless waiting ❊

My breathing gets rapid and my heart races every time I sit in my dentist's office restlessly waiting to hear my name called. Then once I'm seated and held hostage in his hydraulic hoisting hammock, my knuckles turn white while I grip the armrests and wait for torture.

This scene makes me apprehensive. Besides fearing pain, knowing I'll have to open my mouth as wide as possible and expose all my cavities is as threatening as it would be to reveal all of my sordid sins to a spotless saint.

Even though it seems as if I spend my life waiting, I don't wait well. I don't wait well for the dentist. I don't wait well for five o'clock. I don't wait well for the mailman. I don't wait well in the lift line at the ski slope. I don't wait well to be waited on. I don't wait well for food to be served. I don't wait well for my birthday or Christmas or any other anticipated occasion or event.

True to form, I didn't wait well for the start of this war, 'Operation Desert Storm', that our country is now waging.

Recently a woman approached me and said, "Jan, I'd like to ask you a question. As the mother of two military age sons, how do you feel about the prospect of our country going to war?"

"I try not to think about it," was my reply.

Now that the war has started, I've had to take my head out of the sand and do some thinking about our troops, the sons and daughters of other mothers and fathers, who go to sleep every night with their heads literally laying on foreign desert sand.

The reality is the wait is over. Real war has begun–real war with real bullets, real wounds, real pain, real blood, and yes, even real death. Facing the realities of war makes my eyes fill with real tears. Tears of fear. Tears of compassion. And tears of pride.

Now, while restlessly waiting for this war to end, I'm supporting the troops by exercising my faith.

Faith is the most effective weapon I have in my personal arsenal.

Faith is a force mightier than fear.

❋ The memory lives on ❋

The far-reaching and extended family gathered for a picnic-in-the-park celebration of my Uncle and Aunt's fiftieth wedding anniversary. Festive food and friendly, smiling faces helped create a pervasive atmosphere of fun and fellowship.

This setting proved to be the back-drop for an awkward greeting that's uncomfortably and indelibly impressed upon my memory.

On this day, though I greeted and was greeted by countless relatives, it's my cousin Ray and the way we welcomed each other I can't forget.

Ray was born into the family tree about ten years ahead of me, and throughout our childhood we frequently saw each other. Even after we were both grown, married, and lengthy spans of time made our visits sparse, we still saw each other at least every year or two.

We were not strangers.

Though everyone always respectfully greeted Grandma Eva with hugs and kisses, our family had never been demonstrative. Displays of affection were uncomfortable. But so has been this long silent moment after Ray and I warmly smiled at one another when we awkwardly looked into each other's eyes to discern the appropriate gesture of greeting.

I wanted to give him a hug.

He wanted to give me a hug.

We both wanted to let the other know how genuinely good it was to be together.

Instead of sharing a warm embrace, we settled for less than what was desired.

We shook hands.

I thought about the family gathering later that afternoon while driving home. Everything about the celebration left a warm and glowing reflection. Everything, that is, except the fact Ray and I only shook hands. Why hadn't I allowed myself to hug and be hugged!

The next time I saw Ray I would know what to do. That was my resolution and good intention.

�֍ �֍ ✖ ✖ ✖ ✖

A few weeks passed. Labor Day weekend signaled the end of summer and was also the weekend I received unexpected and shocking news.

Ray had died.

✖ ✖ ✖ ✖ ✖ ✖

A year and another Labor Day weekend have past.

It's been a year when, no matter what I did, I no longer could do what I had failed to do. No longer could I give Ray a hug. Despite good intentions, the opportunity is gone.

But the memory lives on and serves as a reminder.

This is the day for living and loving.

Tomorrow may be too late.

❃ There's no place like home ❃

I t was a tornado that whisked Dorothy out of her home in Kansas and placed her in the mystical Land of Oz. Lost and alone, Dorothy quickly made friends with a cowardly lion, a tin woodman and a scarecrow. This unusual foursome traveled together on a magical yellow brick road that led them ever onward toward the Emerald City.

The tin woodman was searching for a heart.

The lion was searching for courage.

The scarecrow was searching for a brain.

Dorothy, who just wanted to go *home,* searched for someone, anyone, who could help her find a way to get there.

My oldest son, Maury recently celebrated his twentieth birthday and the event provided the opportunity for me to do some reflecting.

Because I married when I was nineteen, and Maury is now twenty, I realized I've been married and away from *home* longer than I ever even lived there.

For me, *home* has always been Greeley. The environment of my youth. The place where I grew up and fondly uphold with high regard.

How could it possibly be that *home* was left behind so long ago in my past?

Once upon a time, twenty-two years ago, I was whisked off and away by a whirlwind romance, similar to Dorothy's tornado.

I didn't immediately realize everything this youthful infatuation would mean. Before I knew what was happening and where it would lead, I had fallen in love with my tall, dark and handsome prince.

Hooked and suffering from a devil-may-care attitude, all that mattered was spending the rest of my life with this man of my dreams.

It seemed trivial that I would leave my home, my family, my friends and my familiar comfortable environment. Being with my one-and-only true love forever-and-always was my paramount concern.

Finding the heart and courage, John and I ventured off in pursuit of our life together. I'm a slow learner, so I depended on John to provide the brain.

But it always seemed good to go back *home*. And Greeley remained *home*. It was where I had spent most of my life!

Then, like a sudden bolt of lightning, my son has a birthday and I become discombobulated and forced into rethinking a lifelong frame of mind.

I realized Greeley is now very different from the place that exists only in my memory. Twenty-two years have passed. Friends have moved away. Some have even passed away.

My hometown has grown and changed into a totally different environment, and I've grown and changed into a totally different person. To return there would be the same as starting over.

I recalled getting sick once while visiting there. Instead of feeling at home, all I wanted was to get back home to Calhan, where I had an intact and carefully cultivated supportive and nurturing root system.

Because Greeley provided me with deep roots for growing and strong wings for going, it will always be a mystical residence of my heart. But, the sprawling Pikes Peak plains region east of Colorado Springs has become the *home* of my reality.

Now when I, like Dorothy, say, *"There's no place like home,"* I have the brains to know where it is I'm talking about.

❋ A reason for thanksgiving ❋

"Taking the five loaves and the two fish and looking up to heaven, He gave thanks and broke them...They all ate and were satisfied."

Luke 9: 16 & 17 (NIV)

There was no fast food restaurant or convenient drive-up window. Not even a deli where one could order a precooked meal, complete with all the trimmings.

Yet something miraculous happened that day in a remote area on the far shore of the Sea of Galilee.

On that day the crowd of men gathered to hear Jesus teach numbered five thousand. Who knows how many including the women and children?!

It was late in the afternoon and the disciples were getting worried. They even suggested Jesus should send the people away. Maybe in the nearby villages the throng of followers could find food and lodging.

Instead, Jesus simply told the disciples to find food for the people to eat.

Out of this crowd of five thousand men, only one boy offered his five small barley loaves and two small fish. It was for them that Jesus gave thanks.

Nobody knows in detail everything that happened that day. The accounts in the Bible are brief.

Maybe somehow that small amount of food did miraculously multiply.

Or maybe, just maybe, might there be even more to this miraculous occurrence?

There's a saying: "It's as easy as taking candy from a baby."

I tried it.

A baby knows no greed or selfishness. A baby willingly shares. Ask a baby if you can have a bite of their candy, and it's yours.

Maybe that explains what happened that day on that grassy shore. Maybe when this one young boy with no greed or selfishness

marring his pure untainted character willingly shared his meager amount of food, it miraculously encouraged the adults to share the provisions they had previously hoarded for themselves.

When a hardened human heart becomes willing to share, it is nothing short of miraculous and certainly a reason for thanksgiving!

❄ *Down to the roots* ❄

I've been pulling my hair out. Gray hair by gray hair, I've been pulling it out. At the rate I was going, I knew I'd soon be rid of *all* the gray, clear down to the gray matter inside my skull! (Getting down to the roots was my goal, even if it meant being left without a brain in my head.)

Until recently I hadn't noticed many gray strands of hair. But lately they've been increasing so fast I haven't been able to keep up.

Every day while drying my hair, if I noticed a gray hair I plucked it out. I spent so much time plucking and pulling I was always almost late for work.

All this nit-picking had me primed for a television talk show about women bleaching their hair and becoming blonde. When the program was over, I was ready for action. And fast!

That evening, while my husband was at a meeting, I went shopping for a bottle of magic hair potion.

I'm not very knowledgeable about hair coloring products, so I found myself standing in the aisle reading the claims printed on box after box of various brands.

Faced with all this confusing hype, I began to falter. Instead of diving daringly into this adventure, I opted to purchase a product touted to only add highlights and low lights of color and brightness wherever desired.

With all the gray I needed to camouflage, I wanted color and brightness just about *everywhere.*

Back home, the processing was soon completed. The time had come to wash this goop for the gullible out of my hair. I looked in the mirror. On first sight of my mirrored reflection I knew I'd done it.

I don't know what happened to the promised low lights. All I could see was a head highlighted as if ignited. It had become a brilliant orange flamb'e.

At that moment even total gray would have looked beautiful!

I was glad John got home late that night so I could already be in bed, with the lights off, to avoid facing him.

The next morning, almost before the sun rose, I hopped out of bed. Quickly, very quickly, I jumped in the shower. To keep John from seeing my hair, I kept a towel wrapped around my head turban-style until he was out of the house and on his way for the day.

I was scheduled to attend a luncheon, so once again I found myself standing in an aisle reading the claims printed on box after box of various hair coloring products. This time, however, I had a scarf on my head and no choice but to dive in headfirst and go for broke.

What did I have to lose?

Even though it costs a little bit more, I decided I was worth it and reached for a box containing a bottle of Ash Blonde #8A.

When John got home that evening, even though the deed was done and my hair was dyed, he didn't say a word and neither did I.

I guess he'll find out how I decided between being a blah and boring graying brunette, a bottle baby blonde, or bald when he reads this story.

❋ *Going fishing* ❋

It isn't necessary to go fishing to kindle a special memory. Some of my most treasured and lasting memories of times gone by were almost imperceptibly lured while doing usual things in common settings with people I love–like my three dads.

❋ ❋ ❋ ❋ ❋ ❋

I remember the time I learned the use of feminine charm could be effective in getting my way with my father.

It happened the day of a 4-H roller skating party for all the club members in Weld County. I was about fourteen years old, and because of my developing interest in boys, I knew one particular boy would be there that night.

Because my parents exercised good, prudent judgment and didn't allow much opportunity for serious interaction with the opposite sex, these well chaperoned skating parties were a real highlight on my virtually nonexistent social calendar.

When I got home from school that day and asked Mom if I could go to the skating party, she indicated my social fate would be up to my father.

That evening when Dad walked into the house, I greeted him with a great big hug and a kiss, followed immediately with the big question, "Dad, may I *please* go to the skating party tonight?"

I'm sure Dad saw right through my coquettish behavior, but he gave his permission.

❋ ❋ ❋ ❋ ❋ ❋

When Mom married Robert, he had no children.

Suddenly, after saying, "I do," Robert became stepfather to my brother, my sister and me, as well as an immediate grandfather.

Even though all of this must have been quite an adjustment, Robert seemed accepting of us and adapted quite easily.

Since that day, I've collected many special memories reflecting the bond of love that has grown between us. Interestingly, almost all of them demonstrate Robert's beautiful sentimental nature.

Some men won't cry. No matter what, they won't cry. But I've

often noticed Robert reach into his pocket, pull out his handkerchief and raise it up to his face to wipe a tear or two from his eyes.

I've seen Robert reach for his handkerchief at his acquired granddaughter's wedding as well as during his mother's funeral. I've also seen it as a response to his feelings of patriotism when the flag passes by during the Fourth of July parade, or as an indication of his love and devotion to God when he asks the blessing on Easter Sunday.

Other times, I've felt Robert's tears have been a demonstrated evidence of the reality of his love for me. Those are the times when I especially feel good inside and need to reach for my hanky, too.

❋ ❋ ❋ ❋ ❋ ❋

One Sunday John, Maury, Mickey and I went to John's folks for a family dinner.

During the afternoon I got sick with a fever, chills and increasing back pain. Seeking refuge, I abandoned the gathered family and climbed under the covers in a darkened bedroom.

That evening before we left for home, my father-in-law embraced me with his strong and supporting arms and tenderly gave me a kiss on my feverish forehead.

I recovered from what turned out to be a kidney infection, but I'll always remember the night when I felt like one sick little girl who wanted and needed her daddy. Fortunately for me, Daddy was there.

❋ ❋ ❋ ❋ ❋ ❋

Charles Francis Adams, a nineteenth century political figure and diplomat, kept a diary. One day he entered: "Went fishing with my son today–a day wasted."

His son, Brook Adams, also kept a diary. The same day, Brook entered, "Went fishing with my father–the most wonderful day of my life!"

It wasn't necessary for Charles Adams to go fishing with Brook to kindle a special memory. But their time together sure netted a whopper of a memory for his son.

I wonder if any of my three dad's were aware of the memories they were making?

❊ Weighty words ❊

Once while sliding across Mom's just waxed hardwood floor wearing only bobby socks on my feet, a great big splinter embedded itself deeply into the sole of my foot.

Mom tried her best to tenderly poke and prod at my deeply impaled and injured foot in a futile attempt to remove the offending matter. Quickly she realized more invasive measures would be necessary. Without intervention, the wound would swell up, fester and become all the more ravaged and raw.

Because my Mom reacted appropriately by swiftly taking me to town and checking me into the hospital's emergency room, my resulting scar is hardly noticeable.

I've been thinking about that splinter. My cogitations have been an attempt to make some sense out of being on the receiving end of a crude and rude verbal attack that recently cut right through and impaled my being to the core.

This deluge of words, wielded adeptly in my direction, was tactless and totally unprovoked. Yet, I lamely stood there feeling injured, dejected and disheartened while enduring the onslaught.

After this vicious siege, I retreated without a word of offensive response. My evening had been ruined by an injury so invasive I wouldn't immediately want or be able to talk about the incident.

That night I climbed into bed and went to sleep in silence.

In the light of the following morning, I cleared the resulting residue of strained silence from the air by opening up and exposing the extent of my wound to my husband. John lent me some needed support by telling me he understood why I was feeling pain.

I probably would have gone on suffering in silence. I would have let my infected feelings brood until they became flaming red, ravaged and raw. But, because I confided in a friend, she intervened by telling me this situation was an emergency and I must react with a swift offensive maneuver or tolerate a consequential nasty scar.

I responded by writing a brief two sentence letter which I immediately mailed. My correspondence concluded with, "...your rudeness ruined my evening."

Three days later I received a lengthy, beautifully hand-printed two-page reply. In part this response said, "After looking back, I can see where my remarks were inappropriate and insensitive. For this, please accept my sincere and embarrassed apology...and I may have learned to weigh the effects before opening my big mouth. I'm sorry."

Though difficult, I managed to make a rough cut right to the core of this unsightly matter so I could expose the offense and smooth my wound.

Though this whole experience created personal turbulence, it also made me realize I, too, have undoubtedly uttered offensive offhand remarks that had the power to inflict others with pain.

From time to time we all need to be reminded to weigh the effect of our words–just in case we have to eat them.

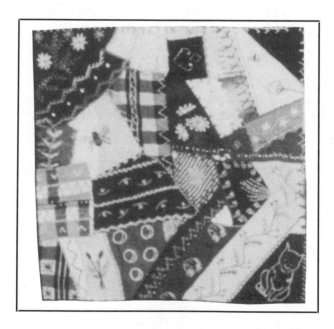

✤ Reflected images ✤

Before heading out the door, I always take one final look into the mirror to see my reflected image. Sometimes I realize I need a bit more blush on my cheeks. Other times I decide I should change shoes. Occasionally I'll notice a run in my stockings and have to take time to change them.

No matter how confident I might have been of my appearance, all it takes is one questionable reaction from any other person to bring on a cold sweat and a severe bout of paranoia. Suddenly I'll find myself desperately searching for a mirror so I can check me out all over again.

I once knew a lady who habitually made me nervous.

Oh, she was nice enough.

Every time I saw her she would smile and say, "Hello *dear*."

But it wasn't her words that cause my insecure reaction. It was the fact that every time she saw me her eyes would start at the top of my head and ever so slowly and deliberately move, covering every inch of my being clear down to the tips of my toes, making a thorough visual inspection.

I have no way of knowing what this person thought. I do know I wanted to sink through the floor and vanish from sight.

Afterwards I always wished I had handled the situation with cool composure and candid candor by innocently asking, "Oh my goodness, is my slip showing?"

Instead, I'd run for the nearest mirror to make sure some spinach wasn't stuck between my two front teeth.

There have been times in my life when I wasn't happy about the way I looked.

I'll never forget going to my high school homecoming dance. I had a date with a good looking young man whose company I enjoyed. My hair cooperated. I managed to put my lipstick on without smearing it all over my face. I even liked the dress I was wearing. The problem was I had sprained my ankle the day before and knew everybody would only notice the anything-but-beautiful elastic bandage that made my swollen foot look gigantic. Besides

that, I couldn't even dance!

Why is it whenever I want to look especially nice, I can count on getting a pimple on my nose, a cold sore on my lip, or a sty near my eye?

In my medical reference book there's a section containing many full-color pictures of yucky human ailments. The purpose of the photos is to provide visual aid for self-diagnosis.

This part of the book helps me count my lucky stars instead of pimples, cold sores and sties. I could have impetigo, boils, shingles, purpura, psoriasis, lichen planus, keloids, seborrheic warts, or even scabies. But of all the afflictions pictured in the book, the one I *least* want is black hairy tongue, a rare, harmless condition in which the hair-like papillae covering the top of the tongue become elongated and dark brown.

I think about how awful it would he to have black hairy tongue every time I go to the dentist.

I just went to the dentist.

Because I'd hate for Dr. Jack to discover anything weird in my mouth, before going I take special care to thoroughly brush my teeth. I even brush my tongue. This particular two and a half hour dental appointment was following a luncheon so after stopping to buy a new toothbrush, I brushed my teeth at every stoplight on the way.

I was cool.

I was confident.

I was ready to open my mouth.

The problem?

I always use a hand held mirror to watch what Dr. Jack is doing.

There are some reflections a person doesn't want to see. I know because I was mortified when, mid-procedure, my eyes became riveted on an ugly black thrush on the roof of my mouth.

I wanted to die.

I couldn't even close my mouth in embarrassment because it was filled with all sorts of surgical steel dental tools.

As my face turned beet red Dr. Jack asked, "Are you still with us?"

Finally Dr. Jack took everything out of my mouth to give me a break, while he and his assistant went to check on the patient getting her teeth cleaned in the next room.

Alone at last, I looked closely in the mirror while scraping the black roof of my mouth with my fingernail. Happily, I discovered the black crud wasn't part of me. Instead of being an attached fungus, it could be removed. Realizing the discoloration was caused by a residue from drilling away the remains of an old darkened silver filling, I regained my composure.

When Dr. Jack came back into the room, I looked at him and with candid candor said, "Boy am I glad the black crud on the roof of my mouth is just sawdust."

After taking a moment to comprehend what I'd said, Dr. Jack started laughing.

Realizing my phobic paranoia really was funny, I started laughing, too.

He and I laughed so hard, I cried.

That's when his assistant came to the rescue by handing me a tissue. After all, what kind of image would be reflected by a lady walking out of a dental office with streaks of mascara stains running down her face?

❋ The encounter ❋

There is no doubt about it!
Feet are not one of God's most beautiful creations.
Functional?
Yes!
Beautiful?
No!

Admittedly, my feet are ugly, but especially in the summer when I wear sandals or go bare footed.

When I was pregnant with my oldest son, my husband commented, "The bottoms of your feet are gross. They're so cracked and stained, when you go into labor you'll disgust the doctor!"

Things haven't improved much over the last twenty plus years, either. One summer Erin, a young and inquisitive friend, asked, "Jan, what's on the bottom of your feet?"

I guess she had never seen feet covered with adhesive moleskin. This layer of artificial skin keeps the calluses on the balls of my feet to a minimum and therefore less painful.

Allowing another person to come in contact with personal body parts, like feet, can be an intimidating invasion of privacy. With this in mind, when I spent the night with my hospitalized mother-in-law, Mable Keller, I cautiously asked if I might massage her body with the costly hospital-supplied lotion.

When she indicated she would welcome a rub down, I began by pouring lotion into the palms of my hands. I started with her feet, carefully applying the soothing and smoothing liquid, even between her toes. As I did, something happened I hadn't expected. A tide of love, more profound than any I had ever previously experienced flowed between us.

When I moved to begin massaging lotion on the unusable thighs and calves of Mable's unresponsive legs, the sense of warmth I was experiencing intensified. As the emollient smoothed her skin, it also worked to soothe away any rough or chapped blemish that had grown in the midst of our very human relationship.

As I prepared to rub Mable's back, it was all I could do to get her

turned far onto one side and resting comfortably against the rail, propped against several cushioning pillows. Once I had her positioned, I continued on with a task that had become a labor of love and devotion. As her dry skin soaked up the lotion, I sensed any lingering disappointment or past pain between us dissipate and vanish.

Mable was extremely proud. The fact she had lost her hair during chemotherapy was devastating, and she had never allowed me to see her when a wig or turban wasn't covering her baldness.

With trepidation I asked Mable if her scalp ever felt dry.

"Something awful," she replied.

Bravely I continued, asking, "Would you like me to rub lotion on your head?"

"That would be nice," was her reply.

I felt so closely drawn to the very essence of Mable's being as I accomplished this desired deed. With absolutely nothing between us, I experienced a very private and sweet communion. With a steady stream of tears flowing down my face, I felt a peaceful freedom that allowed me to express how much I was going to miss this dear lady.

Exactly one week later, almost to the moment, Mable died.

In the month that's passed since her death, I've thought a lot about the private evening Mable and I shared in her hospital room. It reminded me of the Bible accounts of Mary pouring costly perfume on Jesus just days before his crucifixion and death.

Six days before the Passover ceremonies began, Jesus arrived in Bethany...A banquet was prepared in Jesus' honor. Martha served, and Lazarus sat at the table with Him. Then Mary took a jar of costly perfume made from essence of nard, and anointed Jesus' feet with it and wiped them with her hair. And the house was filled with fragrance.

But Judas Iscariot, one of the disciples–the one who would betray Him–said, 'That perfume was worth a fortune. It should have been sold and the money given to the poor.' Not that he cared for the poor, but he was in charge of the disciples' funds and often dipped into them for his own use!

Jesus replied, 'Let her alone. She did it in preparation for my burial. You can always help the poor, but I won't be with you very long.'

John 12: 1-8 (LB)

I was fortunate Mable was my mother-in-law and I'll always treasure her countless acts of kindness and love. How grateful I am I had the opportunity to break through the frail bounds of our human relationship so I could experience a sweet and peaceful communion with her before her death.

My relationship with our Risen Savior is also frequently constrained by those same bounds of humanness. Often I forget, not only did Jesus die, but He died for *me*.

As I draw nearer to His cross during this Easter season, I wonder if, in the moments before my own death, I'll have time to experience a rich and sweet communion with my Lord. Will I be allotted enough time to receive His saving grace and bask in the glory of His peace which passeth all understanding?

Will you?

Can anyone afford to leave this crucial encounter to chance?

❄ *Insurance* ❄

I don't particularly remember any of the other Christmas gifts I gave Dad, but the gift intended for the Christmas of 1966 left an indelible etch.

Even though it was over a quarter of a century ago, I remember I, a then seventeen-year-old schoolgirl, started my Christmas shopping before Thanksgiving. For insurance, I had purchased a soft washable wool shirt to give to my father.

This story, however, really begins with an incident that happened earlier that fall. It was late one afternoon. I'd just gotten home from school. That's when Mom came into my bedroom and told me Dad was going to have open-heart surgery.

I don't recall the total conversation, but I vividly remember looking her directly in the eye and replying, "But Mom, he'll never make it. You know how he reacts to anesthesia."

"Don't ever let him hear you say that," she responded as she turned and left the room, leaving me alone.

At that moment I was one scared little girl. The secure ground beneath my feet was suddenly gone and instead I was being tossed about by the terrible turbulence of uncertainty. It was one of those times when it might have been nice to be an infant with a security blanket to cling to for reassurance and comfort.

All of this is why I can so clearly remember buying Dad's Christmas present at Gregory's. That was the men's clothing store where Bob Caranci and Bill Harrison worked. Bob and Bill were my father's friends. They were particularly capable of helping me choose the shirt Dad would like the best.

After the selection was made, they put the shirt into a box and wrapped it with festive holiday paper and ribbon. When they sealed it with a bow, it somehow seemed official. The present had become my own personal insurance policy. It was something I could cling to, both physically and emotionally. After all, if my Christmas present for Dad was already purchased, he'd have to survive the surgery and be with us to celebrate the holidays.

November 9, 1966, Dad was on the operating table for hours.

Because Dad had rheumatic fever when he was a child, his heart had been damaged. The surgery to replace Dad's leaky and calcified heart valves had gone well. The new valves were in place and the procedure was completed. It wasn't until the doctors switched off the heart machine and attempted to get Dad's heart beating again on its own that everything changed.

In the absence of a heartbeat, Dad's heart and my world collapsed. My dad was dead.

Suddenly my four little words, "He'll never make it," seemed prophetic and came back to haunt me.

It was the middle of the afternoon when the doctor came and directed my mom, my sister and me into a private waiting room off the public waiting room. Everyone else in the waiting room watched us get up and follow the doctor. I think they all knew the news for us would not be good.

I don't remember Mom maneuvering the car through the busy Denver traffic or the long drive back to our dairy farm near Greeley, where my brother had stayed to take care of the cows.

I do remember Mom saying, "Well, the car is paid for. We had insurance on it."

Because Dad realized the risk he was taking, all of his affairs were in order before he entered the hospital. He had written out precise instructions advising Mom. All the important papers and insurance policies were within easy access–just in case.

Unfortunately the insurance plan I had personally taken out on Dad's life still had to be settled. The task proved to be one of the most difficult transactions I've ever managed.

The day when I walked back into Gregory's with my still wrapped and unopened package insurance policy tucked under my arm was the first time I had seen either Bob or Bill since Dad's memorial service. I didn't know what to say to them. In fact, I couldn't say anything.

Because my eyes were filling with tears and I was all choked up, I simply handed back the shirt and left.

During the difficult holiday season that followed, I wrestled with many of life's hard lessons. One lesson I'll never forget is: Somebody has to die before life insurance can do any good.

❋ All choked up! ❋

I can walk and chew gum. I've done it lots of times. I may trip, stumble and fall, but most of the time I can do it. Sometimes I can even talk, walk, chew gum and not choke or fall.

I frequently remind my sons half of their physical ability comes from me. It frightens them.

I suppose many people consider me physically retarded. I'm not ashamed of my disability. It's a reality I've learned to accept because my efforts at moving my body have become a joke.

Due to a sense of humiliation, I shy away from group physical activities. I'm no longer willing to be laughed at. Instead, I've tried to do other things on my own. I bought an exercise record. It came packaged with neatly folded posters of exercise instructions and diagrams.

Unfortunately, I had to give up the exercise record. I couldn't get the posters refolded so they would fit back in the record cover.

Then I switched to children's exercise tapes because the exercises were simple and no diagrams or posters were needed.

Wrong!

Oh, I didn't need diagrams. But let's get serious. How many times could you jump up and down like a frog? I thought I'd croak!

I even forked out the bucks to buy a low impact aerobics video, thinking it would be the perfect answer to my exercise blues and blahs. I could watch the routines demonstrated correctly and I simply had to follow along.

I was in trouble right from the beginning.

First a gorgeous, svelte and smiling woman appears dressed in a beautiful powder blue sequined leotard exercise outfit. That alone is depressing!

Then, like an army drill sergeant, she began giving orders. "Stand with your feet shoulder width apart, back straight, tummy sucked in, buttocks tucked under..."

Oh, I could do it correctly. Even all at the same time. But then I was actually supposed to maintain that posture while I strutted in circles doing a little maneuver called 'chicken arms'. And she was serious!

I think I'll stick to walking and chewing gum.

❋ *Clearer focus* ❋

The day had been enjoyable. Enjoyable, that is, until it came time to pick up my glasses.

That's right. As I've grown older, my arms seem to have grown shorter. I no longer can hold small print far enough away to get it clearly into focus.

A few years ago when I had my eyes checked the doctor said, "Yep, it looks like your zoomer's going."

When I recently returned to the eye doctor, I didn't need him to tell me it done went. I already knew.

With my prescription for reading glasses in hand, I went shopping.

When I first started trying on all the different frames for glasses, I felt like a spectacle when I looked at my mirrored reflection! A real sight for sore eyes!

After a while, however, I began to focus on the more flattering styles.

As I tried on pair after pair of frames, I thought about how my husband John and I had made a special trip to Colorado Springs about a year ago so I could help him decide which frames to order.

"Can a woman order glasses without having her husband along?" I asked the male clerk assisting me.

After a long pause, his well thought out reply was, "A woman can pick glasses without her husband–but a man can't pick them without his wife."

Knowing exactly what he meant, I confidently made my selection.

A couple of weeks later my glasses were ready and waiting to be picked up.

I wished I could go to some private mirrored cubicle to try on my glasses. But I had no choice. I had to try them on so the fit could be checked in the presence of the whole world as well as a friend who was with me.

"They make you look bookish," was my friend's initial reaction.

I wasn't sure, but somehow her evaluation didn't feel like a compliment. Then again, her appraisal might have been downright negative, so I took comfort in the fact I only need to wear them for reading and close work.

When I got home and tried on my glasses, my husband sounded

sincere when he said, "They look nice."

The first day when I put them on at work I felt very conspicuous. Several co-workers made comments like, "You haven't worn glasses before, have you?" Or, "I like your frames."

It was my boss, Monty Gaddy, however, who helped by saying, "Your glasses make you look very professional. And that's a compliment."

That evening at home I had a stack of monthly bills waiting to be paid. When I had them piled up in front of me, the task seemed insurmountable. Thanks to my glasses, however, I could easily read the amounts that were due. Soon I had the checks written and envelopes addressed.

With my mission accomplished, I removed my glasses, turned off the lights and headed for bed.

I was late, as usual. Though the movie theater was dark; there was just enough light to see an empty aisle seat. I could tell I hadn't missed anything except the previews of coming attractions.

Because my stumbling around in the dark seemed to disrupt others in the theater, I quickly settled down and relaxed into the upholstered seat, ready to be entertained.

The movie was about half over when I realized my lips were uncomfortably dry. Seeking relief, I reached for my purse and started digging around in its depths for a tube-shaped object.

As I unsuccessfully fumbled around, I could tell my actions were annoying the people seated near me. Trying to speed things up, I took the large objects, like my billfold and glass case, out of my purse and put them on my lap.

Just as I located a tube of soothing balm, my plastic glass case fell to the floor. This initial crash was followed by the sound of it sliding some distance down the auditorium's natural incline. As the entire theater audience turned to look in my direction, I was grateful to be shrouded in darkness.

Hoping nobody would realize exactly who was to blame for all the noise and disruption, I sat still and didn't even look down to

watch where the case was heading as it slid farther and farther away.

As soon as everyone else settled back into the movie, I reached down by the side of my seat. When I felt the special soft cloth I'm supposed to use to clean my glasses, I knew the case had popped open on impact and I was in trouble.

What if my glasses were broken?

I started looking under the row of chairs in front of me and then began searching with my feet, but I couldn't see or feel anything.

The movie I was supposed to be watching was a comedy, but I wasn't laughing. Not even at the funny parts. I kept thinking, "What if the people in front of me, the ones who have acted so annoyed, step on and break my glasses when they get up to leave?"

At the end of the movie, the people in front of me filed out of their row. I was relieved when I didn't hear anything crunch.

As soon as the auditorium was empty, I got down on my hands and knees and began searching the gross and sticky floor. Finally I found my glass case; but where were my glasses?

Eventually an usher came with his flashlight and helped me search.

"Don't the auditorium lights ever come on?" I asked.

"No," he replied.

Soon, however, he abandoned me. He said he had to go collect tickets for a movie that was about to start in one of the other auditoriums within the same complex.

I felt foolish fumbling around on all fours in the dark. I felt downright dumb, however, when the light in my mind clicked on and I realized I didn't even have my glasses. They were at home where I left them after paying bills the night before.

As I was leaving the building, the usher saw me and asked, "Did you find your glasses?"

"Yes," was my almost-honest reply.

❀ ❀ ❀ ❀ ❀ ❀

Now I can put my life into clearer focus.

Besides worrying about losing my glasses, I also have to deal with the realization I'm losing my mind!

❋ *Wherever I go* ❋

The first night we lived in the house, John and I held tightly to each other in the quiet darkness. We were little more than a couple of frightened kids clinging to each other for support. Buying our first house was the scariest decision we ever made.

When we initially looked at it, the house was filled with another family's possessions and making an offer to buy it seemed logical and sane. But the house appeared very different when it was empty. Suddenly, every room was dying for a fresh coat of paint and most of them needed a major overhaul.

We could see a lot of work waiting to be done, even though we didn't have much financial reserve to do it. Buying the house required every bit of money we could put together.

"Have we made a mistake?" I asked, as John and I huddled together.

"I don't know," was his all too honest reply.

The next morning we were more than a little surprised to look out and see the sun shining on a bright new day. Its warm and radiating glow provided the encouragement we needed to roll up our sleeves and get to work.

When I think of the first few days we spent in the house we've called home for over twenty years, I remember John and I weren't the only ones who found it a frightening and unsettling experience. So did our young sons, Maury and Mickey.

They were just little guys, Maury three and Mickey one, when we first moved into a house that must have seemed enormous–especially after the cramped conditions we were used to living in.

Often while I was busy unpacking and settling in, I would hear one of boys crying with all his might. Quickly I'd run to see what was wrong. Usually I'd find one, or maybe even both of them, sobbing hysterically in the middle of the hall, upset because they thought they were home alone.

Soon this new environment became comfortable and the boys grew to enjoy the advantages of more space. Each of them could even spread out in his own separate bedroom.

Over the years we tore down, built up, remodeled and

recreated the house into a home. Our home. And in our home, especially during all the active years of raising a family, there was a whole lot of living, laughing and loving going on.

Recently I spent my day cleaning our home one last time. It proved difficult because our home, stripped of its personality, had become unfamiliar and empty. Everything we owned had been packed away in boxes. The personal treasures that had hung on the walls were gone.

With all of our possessions moved out, it was easy to make my way from room to room washing windows, dusting baseboards, vacuuming carpets, cleaning the kitchen and sanitizing each bathroom. It was well past midnight before all the tasks were completed.

One final time I went through the house. As I did, I turned on every light in every room. In the midst of the house's stripped interior, I sensed my own protective layers of emotional insulation disintegrating. I felt unprotected and bare.

After giving each room a final review, I sat down in the middle of the living room floor and saw this house as mine for the last time. My surroundings, though intimately familiar, now seemed foreign.

That's when I couldn't put it off any longer.

The time had come for me to go.

I got up, turned off the lights, locked the door and silently left.

The next day my husband and I met with the new owners to inspect the house and transfer possession.

It's not our home anymore.

❇ ❇ ❇ ❇ ❇ ❇

Instead of two young sons feeling confused and uprooted, this time it's our two puppies, Kirby and Capri. They stand in the hall and bark hysterically because they think they're lost and alone in strange new surroundings.

Surprised by this unexpected move, people have asked, "How could you sell your home and leave all your memories behind?"

I respond with a shrug because I know we only sold our house. Our family can still live, laugh and love whenever we're together.

And, as for my memories, they go with me wherever I go!

❊ Problems ❊

Sometimes a person is forced to learn the difference between problems and inconvenience. If my house were on fire, I broke my neck or were starving, I'd have a problem.

Life is an obstacle course of inconveniences to navigate around. The course of every life is filled with inconvenient lumps and bumps.

❊ ❊ ❊ ❊ ❊ ❊

I thought I had a problem.

I was laying flat on my back on a gurney out in the middle of the hospital's radiology department waiting to go back into the CT scan room. The radiologist was telling me he'd have to insert a drainage tube into a very large abscess that had somehow developed in my pelvic abdomen.

"I'm going to call a couple of specialists, a surgeon and a gynecologist, onto your case," said the doctor.

"Wait! I replied. "First we have to find out which ones are accepted by my insurance company."

"I don't think you understand," continued the doctor. "This is an emergency."

❊ ❊ ❊ ❊ ❊ ❊

I thought I had a problem.

I'd been in the hospital for several days receiving three or four different antibiotics intravenously and now all my veins were either blowing up or shutting down. Finally, all the doctors agreed I could safely be switched to oral medication.

The good news: I would soon be able to go home.

The bad news: When I went home, it would be with the drainage tube and collection bag still connected to my body.

�֍ �֍ ✖ ✖ ✖ ✖

I thought I had a problem.

In the process of diagnosing the abscess, the radiologist also found a tumor on one of my ovaries.

The doctors kept telling me how very fortunate I was to have avoided surgery to drain and remove the abscess. They said cutting infected tissue is like cutting cornbread. It crumbles.

I kept thinking, "Why do they say I'm so fortunate? Because of the tumor I'll have to have surgery anyway. Why can't the doctors just take care of everything all at once? And what's so bad about cornbread? Even crumbs taste good!"

✖ ✖ ✖ ✖ ✖ ✖

I thought I had a problem.

It was just about time for me to go back into the hospital to have the tumor removed. I suppose I should have been concerned about important things like the possibility of malignancy. But because I had decided not to borrow trouble, cancer wasn't something I stewed about.

Instead, the surgeon upset me, saying, "If, when we operate, we find the abscess was caused by intestinal diverticulitis, you'll be in the hospital for a week to ten days."

"But the gynecologist said I'd be able to come home in three days!" I emphatically responded.

The surgeon didn't even so much as acknowledge what I'd said. He just continued on as a professional bearer of bad news, saying, "And, you'll have to be prepped for intestinal surgery."

After learning the nitty-gritty of what this entailed, I protested with obvious frustration.

The doctor unsympathetically dictated, "You *will* be prepped!" Then with a slightly softer voice he added, "Otherwise, a colostomy might have to be performed."

❋ ❋ ❋ ❋ ❋ ❋

I thought I'd endured a whole string of problems.

I got sick the weekend prior to Thanksgiving and wasn't able to go back to work until the middle of January. I not only totally missed Thanksgiving, but my Christmas and New Year's holidays were masked by a dark and gloomy cloud.

I'm able to put all this into clearer perspective now that the surgery is behind and I'm feeling better.

I am lucky and do have a great deal to be thankful for.

I'm thankful for competent and compassionate health care professionals with skill to utilize antibiotics and advanced medical procedures.

I'm thankful the abscess wasn't caused by diverticulitis and I could go home three days following surgery.

I'm thankful the tumor was discovered, removed, and proved to be benign. And, most of all, I'm thankful for the support and love I received from my family and friends.

Because the whole ordeal, like life itself, has been bumpy and lumpy, I've learned to discern a difference in lumps. A distasteful lump in the gravy, a sore lump on the shin, and a malignant lump in the body are not the same lump.

In retrospect, I guess I never really had a problem.

What I had was inconvenience.

✽ Monumental events ✽

This spring has been a season of monumental events, including a silver wedding anniversary celebration honoring my folks, Robert and Millie Frank.

I didn't realize this year was Mom and Robert's twenty-fifth anniversary until about a week before the actual day. In a panic, I called my brother and sister, only to discover they, too, had forgotten. (Great kids, huh?!)

My brother Bob said, "Maybe we could take them out to dinner somewhere really nice."

"Maybe," I responded. "But I think I remember Mom saying she wanted a party when she and Robert celebrated their twenty-fifth anniversary. I think I'd better find out what Mom and Robert would like."

Immediately, I called and asked them.

"Oh," replied Mom, "it might be nice to have just a few close friends come to the house for cake and ice cream."

"That will be fine," I responded. "Just get your guest list put together..."

I don't think an hour had passed when my telephone rang.

"Jan," I heard, recognizing Mom's voice, "I think we'll have to use the church basement..." How quickly the small party with just a few close friends had grown!

About three weeks later the occasion was celebrated in the company of around two hundred and fifty friends and relatives.

A meaningful highlight of the day's festivities was the presence of Reverend Tom Ewing. My natural father, Oliver Goldsmith, had served on the committee responsible for selecting Reverend Ewing as pastor of the Presbyterian church my family attended. As time would have it, Reverend Ewing ministered and supported my family through many monumental events.

He officiated at Dad's memorial service.

He married my brother Bob and his wife Connie, my sister Lois and her husband Jim, as well as John and me.

He baptized my sons, Maury and Mickey, at the baptismal fount built with memorial gifts honoring Dad.

Then, coming full circle, he married Mom and Robert.

Twenty-five years later, Reverend Ewing came from out-of-town to offer a special blessing for Mom and Robert on their silver wedding anniversary.

❈ ❈ ❈ ❈ ❈ ❈

About a month after the anniversary party Mom celebrated her seventieth birthday. Because this was another monumental event, I wanted to host a surprise party for her.

Robert helped me put together a list of Mom's friends and, as I was preparing the invitations, I came up with the idea of asking each invited guest to bring a single silk flower to include in a younger-than-springtime birthday bouquet.

The party was set for ten a.m. on Mom's birthday. Robert's job was to get Mom out of the house by taking her out for breakfast. While they were gone, my daughter-in-law Lana and I moved into action. Very quickly we unloaded my car and made our final preparations.

All but a couple of Mom's friends were able to attend the party, so cars were parked up and down the street for a couple of blocks.

When Robert returned with Mom, as they pulled up in front of their house he casually said, "One of the neighbors must be having a party."

"Well," replied Mom, "I think it takes a lot of nerve for one of *their* guests to park in *our* driveway!"

As Mom walked in and saw her house filled and overflowing with friends, everyone started to sing, "Happy birthday to you..."

When the song was over and Mom regained enough composure to speak, she got quite a laugh when her first stammered words were, "Excuse me. I have to go to the bathroom."

The party was a successful surprise, and thanks to Lana, the floral birthday bouquet was beautiful.

�֍ �֍ ✖ ✖ ✖ ✖

When I think about both of these monumental events another happenstance comes to mind.

It occurred a few days prior to the anniversary party. I remember because I drove up to Greeley to spend the night with Mom and Robert and make sure everything was in order for their celebration.

The next morning while the three of us were eating breakfast at a neighborhood restaurant, I became aware of an elderly man seated behind Mom and Robert. I noticed him because he kept staring at me. Every time our eyes happened to meet, I uncomfortably looked away. Though I tried not to look at him, I noticed he was eating alone. Mom, Robert and I continued to eat and visit, all the while with this man continuing to stare.

When we were ready to leave the restaurant, we got up and walked right past the table where he was seated. As we did, he asked, "Are you and your parents enjoying a nice visit?"

Realizing he wasn't a character to be feared, I smiled and warmly replied, "Yes. I'm spending a couple of days with them."

"Enjoy them while you've got them," he said.

"I will," was my reply.

❃ The dawning ❃

As I stood in my kitchen getting some cinnamon rolls ready to bake, I looked out the window and realized it was the very first time I had been up early enough to see the dawning of new day in our new house.

In quiet solitude I reflected back over the month since we first moved in.

I almost laughed out loud when I recalled the first time I tried to cook in my new kitchen. Our first festive feast had consisted of frozen pizza. Without the foggiest notion of how to even turn my oven on, I just stood there staring at the controls. Suddenly the eternal silence of my perplexity was broken by the sound of my youngest son, Mickey, trying to contain his desire to break out in hysterical laughter.

"What's so funny?" asked I, an absolute retard in today's incredible world of electronic wizardry, who has to wait for this same son to get home from college so he can set the clocks on the microwave and VCR every time the electricity merely flickers.

With not so much as an offer to help me master the menial mechanics, Mick matter-of-factly replied, "Mom, I told you were buying too many digital appliances."

"But Mick," I defensively replied, "that's all they sell!"

Just then our dogs, Kirby and Capri, traipsed into the kitchen and interrupted my recollecting. They had come to check on what I was up to at a time when they know I'm usually still in bed. Following close behind was Barkley, my grandpup.

Barkley belongs to my oldest son, Maury, and his wife, Lana. Maury, Lana and Barkley had spent the night with us. Because I could hear the shower running in the basement, I knew Maury and Lana were awake and starting to rouse.

Just a few days earlier, Lana's father, Leon Hamacher, had died. He had waged a gallant war with cancer and inspired us with his courageous spirit. We mourned his death and shared in Maury and Lana's sorrow and grief. This day that was dawning was the day of Leon's funeral.

As I looked out my window I noticed the sunrise wasn't too brilliant. It didn't glow with vibrant color. To myself I thought, "How appropriate. Even the sun is mourning."

But the sun did rise, and a new day did dawn.

The pans of cinnamon rolls came out of the oven just in time to send them along with Maury and Lana to her family for their breakfast.

Once again alone in my kitchen, I turned my attention to cleaning up. With my hands submerged in a sink filled with warm and soapy water, I thought about the laughter and the tears our family have experienced since moving.

And that's when it dawned on me.

Our new house has become more than just structural walls.

It has become a shelter where it's safe to expose vulnerabilities and even laugh at yourself and your shortcomings. It has become a haven from life's storms, offering outstretched arms to embrace and support while releasing welled-up tears in times of grief. It has become the place where we live, laugh and love. Together.

It's home.

❊ The Present ❊

Yesterday is history.
Tomorrow is a mystery.
Today is the gift - that's why we call it 'The Present'.

–Anonymous

I have a habit of walking through life with my head turned around so I can keep one eye looking behind me to my past. This is good to keep me reminded of where I've been and how I got to wherever it is that I am. Unfortunately, it doesn't work very well.

Often I get tripped up.

Sometimes I get whammed.

On occasion I've even rammed right into brick walls.

On the flip side, I'm always planning or organizing something and have my other eye focused on the future. Tomorrow. Next week. Or even next year.

By paying so much attention to where I've been and where I'm going, I sometimes look at the world askew, get a crook in my neck, and haven't the foggiest notion of where it is that I presently am. The consequence is it's easy to miss out on the special unique beauty of what's going on in the here and now.

An event like the recent tragic bombing in Oklahoma City serves as a clear reminder that this is one heck of a way to go through life. For it's what we make of today that counts. Only in the here and now are we properly positioned to be able to give and receive the simple and spontaneous gifts of 'The Present' with family and friends.

Recently I *gave* a gift of 'The Present when I approached a new friend during a break at a formal gathering by openly and honestly saying, "I'm really enjoying getting to know you better. You're a neat person and a lot of fun!"

She seemed a bit flustered and responded with a chuckle and said something to the effect of, "Well, I am kind of a strange bird."

After the meeting was over she hunted for me. When she found me she said, "You know, I didn't know how to respond to you. I've never had anybody say anything like that to me before."

Recently I *received* a gift of 'The Present' when a friend chose to share a precious, very closely guarded and personal confidence with me. Opening up and becoming vulnerable did not cause the self to leak away. It let friendship's love pour in.

Recently I *shared* in a gift of 'The Present' at a Christian Women's Weekend Retreat with a group of area ladies. By getting away together, we discovered new relationships could take root while existing ones were nourished and afforded an opportunity to grow and deepen. Through joyous laughter, tender tears, compassion and encouragement, we were drawn closer to one another and our Lord. When we went our separate ways and returned home, it was with a new song in our hearts.

Gifts of 'The Present' constitute beautiful multifaceted miracles created especially to be appreciated and enjoyed in this moment, today.

They are the rare and real treasures of life.

❋ Cinnamon toast ❋

When I heard a single chime ring out through the pitch blackness of the middle of the night, I raised my head to see what time was illuminated on our alarm clock. "It's only one o'clock?!" I thought to myself. "How can that be?" Had I really been tossing and turning for only a couple of hours, instead of the eternity it seemed?

I wrestled with my unsuccessful effort to go to sleep for twenty more minutes before I was suddenly struck with an inspired craving for cinnamon toast. Not just any cinnamon toast. In the middle of this particular night, I wanted the kind my husband John and I have come to refer to as Dad's cinnamon toast.

Dad's cinnamon toast is one of my comfort foods. It's something I'm apt to desire at times when a little girl might seek the comfort of her daddy's lap, coupled with the protection of his strong arms. Any time I'm sick, upset, confused, or just can't sleep is a perfect time to seek the comfort and solace of this particular nourishment.

Dad had his own way of making cinnamon toast. A way that John rarely attempts to mimic and my sons don't even like. John never tasted cinnamon toast Dad had made so how could I expect him to recreate it? And my sons? They prefer to have cinnamon and sugar premixed together in a shaker to sprinkle on their hot buttered toast.

With Dad's cinnamon toast on my mind, I knew the only way I would ever get any sleep was to get up and make some.

The first thing to understand about Dad's cinnamon toast is that it was a rare and special treat. Dad was a dairy farmer so he was usually out milking the cows when breakfast was being fixed. Only on those sleep-in-a-little-later-than-usual mornings would Dad be involved with breakfast preparations.

Another thing about his version of cinnamon toast is it's not concocted for the calorie counter or cholesterol conscious. Dad's side of the family lived by the philosophy if a little is good, a lot is even better, especially when it came to ingredients like butter and sugar.

I quietly made my way through the dark house to the kitchen. There I turned on just enough light to sort of see what I was doing. After pausing long enough for my eyes to adjust to the light, I turned on the oven. Next I got the bread out of the pantry and the toaster from the cupboard. While a couple of slices of bread were toasting, I collected a knife and pan as well as the butter, sugar and cinnamon. When the bread slices were toasted to a perfect golden brown, I quickly smeared on an ample amount of butter, then piled on as much sugar as the butter could absorb. On top I sprinkled exactly the right amount of cinnamon before putting the slices on the pan and popping them in the oven. While the toast reheated and butter saturated through the cinnamon, I reached for a glass and proceeded to fill it up with milk.

When I sank my teeth into this warm and wonderfully tasty treat, I closed my eyes so the focus of my attention would be totally engrossed in my recreation of special childhood memories. Though it's possible for me to conjure up a batch of cinnamon toast when I want to make Dad seem a little nearer, the reality is he died many years ago. Indulging myself with his cinnamon toast is about as close as I can come to spending time in the pleasure of his company.

When I climbed back into bed, I drifted into a restful slumber with a song from Disney's classic animated movie *Cinderella* going through my mind. Over and over to myself I sang, *"A dream is a wish your heart makes..."*

The next morning I thought about dreams and how important it is to be aware of the difference between an attainable aspiration and a fantasy. An aspiration that's teamed with determination and effort has the potential of becoming an attainable reality. A fantasy, no matter how fantastic, is doomed to remain in the realm of make-believe.

Dad's cinnamon toast was a dream. Whether this particular dream was a realized aspiration or a make-believe fantasy isn't important.

What matters is I enjoyed Dad's cinnamon toast and was comforted.

❊ Reconstruction ❊

I remember the night after Amber Fetters was struck and killed by lightning this past July was, for me, sleepless. Because Amber (a bright and beautiful seventeen-year-old 1995 Calhan High School graduate) and my youngest son, Mickey, had seriously dated for the past couple of years, my midnight musings sought wisdom and counsel capable of shedding light on an appropriate way to deal with the tragedy.

A dusty memory that kept recurring as I tossed and turned was of an interview I had in March of 1985 with Kay (Richardson) Book, of Rush. Realizing I wasn't about to go to sleep, I got out of bed in the middle of the night to dig out and go through scrapbooks. After leafing through volumes of personal archives, I located the article in question. Near the end I found Kay's memorable and enduring words when I read, *"...God doesn't control everything that happens to us, but He helps us control what we're going to do with it, after it happens."*

After copying the quote, I took time in the quiet predawn solitude to quickly jot a note to Kay's family. I thought it might be nice for them to know, even ten years after the interview, Kay's words and wisdom were meaningful and remembered.

❊ ❊ ❊ ❊ ❊ ❊

Prior to my interview, Kay and I were not close friends. Though Kay and I knew each other and had developed a mutual respect, it was her sister, Verna Ververs, and I who shared the close friendship. Through Verna, I knew a great deal about Kay.

I knew Kay had grown up in the Simla community and, as a 1966 high school graduate, was my age. When Kay married Keith Book, she moved; and the young couple made their home in the Rush community, where Keith had been raised. Even though Keith and Kay desperately wanted to start a family, actually having children of their own required the help of doctors at Colorado University Medical School. Their two children, Kent and Kara, were a dream come true.

In 1980, when Kent and Kara were seven and four years old, the young family's idealic existence was shattered when Kay, then thirty one years old, was diagnosed with breast cancer. Between 1980 and our interview, I heard numerous stories about Kay and the way she maintained her upbeat outlook and optimistic attitude while battling the disease.

In 1984, almost four years after the initial malignancy, two more lumps were found and Kay underwent more surgery and chemotherapy.

When I interviewed Kay in March of 1985, her recent tests and scans showed no trace of cancer present in her system. As a preventative measure, she was taking low-dosage maintenance chemotherapy for five days every month with an auto-syringe pack that administered the drugs directly into her system. The pack, which was worn like a shoulder strap purse, allowed her to continue with her normal daily routine.

✤ ✤ ✤ ✤ ✤ ✤

I'm a person who takes friends and friendship very seriously. I willingly invest a lot of time and attention toward maintaining meaningful relationships. On the flip side, I have little or no time for superficial small talk. If people disclose and reveal who they are deep down inside and connect with me by becoming my soul mate, they're a friend. If they don't, they remain an acquaintance.

When Kay opened the door of her home on March 8, 1985, to Jan Keller, journalist, she also opened her heart and soul to Jan Keller, friend. During the course of that afternoon together, I became overwhelmed by the degree Kay candidly disclosed details of her physical and emotional trials and the incredible trust she placed in me for the way I would ultimately share her story with *Ranchland News* readers. Yet even Kay's frank verbal disclosures did not prepare me for the way I would be deeply and forever impacted by my interview with this very remarkable lady.

I regard what transpired that day between Kay and I as sacred and spiritual. For not only did she disclose the core of her very essence,

but slowly and intentionally, button by button, Kay opened up the front of her blouse and exposed her private, personal and physical self so I could fully appreciate the scarred but beautiful reconstructed breasts that once again allowed her to perceive herself as a whole and healed woman.

Never before, or since, have I experienced anything in my personal or professional life that moved me so deeply. The profound intimacy and rare purity of that incomprehensible moment bound Kay and I in a unique and everlasting friendship. I felt a deep sense of loss when Kay died two years later on April 10, 1987.

❀ ❀ ❀ ❀ ❀ ❀

There was a stack of mail waiting on the kitchen counter when I got home from work. Quickly I leafed through the envelopes, immediately going from one to the next without opening any of them until I came to an envelope embellished with beautiful bright roses. When I noticed the return address indicated the letter was from Kara Book, Kay's now college-age daughter, I immediately stopped to open it.

Inside I read:

"... Jan, the little note you wrote to Dad after Amber died meant the world to us. Thank you. It's always nice to have anything of Mom's to hold onto, especially words of wisdom, particularly at this time in my life when I really wish I could have known Mom as a person and a friend. This leads me to my main reason for writing. Dad said you did quite a few interviews with Mom and wrote a lot of articles about her. If you still have these materials, I would really appreciate copies of anything! I also would love to hear anything else you might want to share about Mom..."

Ironically, Kara's request for information about her mother arrived on the anniversary date of my father's death. Because I realize the value of anything that helps to keep the memory of a deceased loved one alive, I immediately gathered everything I have about Kay and sent it on its way.

...And she brought forth her firstborn son, and wrapped him in swaddling clothes, and laid him in a manger; because there was...

❋ No room ❋

Sunday morning I took a brief detour during the church service to thumb through the hymnal to look at the variety of Christmas Songs included in the book.

I discovered there were songs about shepherds, angels, cows, sheep, mangers filled with hay, stars, wise men, love, joy, peace and a newborn babe–but not one single solitary reference or music note dedicated to the fact that, without the aid of a throng of angels to put the fear of God in the shepherds, or a bright star to capture the attention of a trio of wise men, mankind had no room for that first Christmas morn.

I was intrigued by the realization the beloved carols of the season cover every other aspect of the Holy event, yet leave a gaping omission of inherent oblivion. Mankind chose, and continues to choose, to ignore its self-centered and egotistical callousness rather than face it, or, heaven forbid, correct it.

This Christmas is no different, and we're no better.

Society has gotten so tripped up on the trappings of Christmas we continue to have no room.

We focus so much attention on the commercial side of Christmas our plastic money is maxed out. We're shocked, insulted and embarrassed when a store clerk is forced to reject a desired purchase because our credit account has no room.

We overindulge in rich gluttony until there is no other choice but to push away from the table and loudly proclaim, "No room."

We keep such fast paced and stressful lifestyles our personal schedules allow no room.

Will this be the year when we finally clear out some of the unimportant superficial clutter in our lives and allow ourselves to give and receive the precious gift of love?

All it takes is a little bit of room.

Luke 2:7 (KJ)

✸ Dum-De-Dum-Dum ✸

My name's Friday. Jan Keller-Friday. I'm a cop. I became a cop, or at least an investigator of sorts, last Monday. Or was it Tuesday or Wednesday? Actually, it could have been Thursday, but that's beside the point.

All I wanted were the facts. Just the facts, ma'am.

Dum-De-Dum-Dum.

The story you're about to read is true. I haven't even changed the names to protect the innocent.

Recently the accusation was made that I *overreact.*

Because I admittedly suffer from an acute level of paranoia, I reacted by conducting my own thorough investigation to determine my personal guilt or innocence to the charge.

Seeking counsel, I visited my friend Janet.

Direct to the point, the first words out of my mouth were, "Do I overreact?"

Somehow realizing there was probably more to the question than three little words, Janet paused to consider how best to state her thoughts. She then carefully proceeded, saying, "No, Jan wouldn't say you overreact." Then, as an afterthought, she quickly added, "But you do *act.*"

As a tell-me-more expression spread across my face, Janet instinctively realized I wasn't about to let her off the hook that easily, so she proceeded, saying, "Most people skirt an issue, trying to avoid doing anything about everything for as long as possible. You don't. You take action."

As I thought about Janet's reply, my mind went into a state of instant replay, recounting a couple of past interactions evoked by her comments.

First I thought about a conversation with Jack Lawson. Jack, who my husband John and I contracted a couple of years ago to build our house, had accompanied us to a meeting with the draftsman who was designing and drawing our blueprints. During the meeting the draftsman gave us a questionnaire to fill out and bring back to our next meeting.

As soon as John, Jack and I left the meeting and got into our car to head for home, I immediately started asking John the questions and filling out the form. This caused Jack to ask, "Does she (meaning me) ever procrastinate about anything?"

"Never!" was John's direct, single word reply.

The second incident that came to mind was a conversation I had with Pat Farrell and Susan Johnson, staff members with the El Paso County Parks Department. As the three of us were visiting just prior to a recent Park Board meeting, Pat chuckled aloud and stated, "That's what I like about Jan. She goes for the kill and gets right to the point."

Dum-De-Dum-Dum.

In the courtroom of my mind, I, Jan Keller Friday, accused of 'overreacting', not only served as the defendant, but also as the prosecuting attorney, defending attorney, bailiff, court recorder and chief investigating officer.

Now that the arguments had been presented, I shifted my attention and energy to becoming the judge and jury.

After due deliberation, I banged my gavel.

The verdict: NOT GUILTY.

I do in fact act. I act quickly, decisively, and directly to the heart of an issue. It's just me and my inherent nature. Whether others would consider me guilty of the crime of 'overreacting' is an individual discretionary call. They'll have to render their own decision in the case according to their own personal criteria.

The case is closed.

For me to spend any more time worrying about it would be overreacting and Dum-De-Dum-Dum-*D-U-M-B!*

❋ O-o-o... A-a-h... and U-g-h! ❋

Most folks, guys and gals alike, take a few moments daily to sit in private and contemplate the world while attending to their personal business. It's a regular matter-of-fact body function that's seldom discussed except in hushed tones or the doctor's office.

One day while perched on my throne, with pants dropped and draped around my ankles, I noticed a label sewn into the side seam of my slacks.

On closer inspection I realized this little snip of ribbon was embroidered with four little words. This unusual and unexpected discovery had a profound and mighty impact. Even though this occurred several years ago, it was so provocative I've remembered the way it perked me up and changed my day.

What was the invaluable message I discovered at that most inopportune time?

"Today You Look Beautiful," was the simple but never-forgotten vital and uplifting message I found woven into the very fiber of the ribbon.

Oh how I wish I had such a positive message permanently etched into the core of my being, dispelling doubt and insecurity at times of ugly and awkward uncertainty.

Who doesn't enjoy, and actually need, someone occasionally o-o-o-ing and a-a-h-ing over a new outfit, cute haircut, or a great personal accomplishment?

Though a compliment may be among the kindest gestures and most valuable gifts human beings could bestow upon one another, in monetary terms, the cost is only a moment of unselfish consideration.

Why is it we're willing to make positive comments about an individual's capabilities or talents to almost anyone except the person being referred to?

What causes us to be frugal, even down right stingy, about recognizing and rewarding the positive attributes and appealing qualities of the people we associate with and often regard as friends?

How much does a fuzzy stroke cost when compared to the warmth provided to offset the chilly blasts from a cold and cruel world?

If the economic rules of supply and demand were applied to compliments, their scarcity would render them so costly we couldn't afford to give them or even pay the imposed gift tax when and if we were fortunate enough to receive one.

Because it was an isolated incident, I've often wondered if that satin side seam message was a random act of kindness, providing a source of pleasure to some anonymous assembly line worker in a clothing factory.

If Levi or Liz explored this incredible marketing technique by routinely sewing a similar label into their garments, I would be tempted to become a faithful regular customer!

Even though those four little words packed the power to bolster my self-esteem and make me feel, if even for a fleeting moment, as if I possessed unlimited possibilities, they didn't cause my head to swell or diminish my perception of reality.

I knew I did not look beautiful at that particular, u-g-h, moment!

❊ Turned on ❊

"All right, Jan. You can turn it off now," a friend once told me when my enthusiasm for a certain pet project had reached the bubbling over point and my zeal was enough to drive anybody crazy.

That's how I am. Once I delve into something, it's nothing short of a whole-hearted all-embracing unmistakable turn on.

Lately I've been turned on and fired up on all burners with an extreme overdose of adrenaline! The word enthusiastic doesn't even come close to describing my current charged-up condition.

I've thrown myself into my current pet project with enough zest to create enough scrubbing bubbles to clean the entire universe.

My husband says, "But Jan, do you have to live it and breathe it?"

Sporting a smug little grin, I reply, "At least I don't sleep it."

"You can say that again," John quips back. "You don't sleep. You go to bed, and then, because you're unable to relax and unwind, you get back up and keep working on it at all hours of the night."

John's right. If I were a spring, I'm wound up so tight I'd tell you, "Stand back, watch out and be ready to jump!"

It really doesn't matter what the fixation is I'm currently so engrossed in. What does matter is I feel really alive when I'm an enthused and stimulated dynamo who's fired up, charged for action and ready to go.

Rutty and regular routines are all too easy to get bogged down and stuck in. I feel an exhilarating surge of energy when I take on a challenge that stimulates my imagination, stretches the boundaries of my capabilities, allows me to grow intellectually, and redefines my competency.

"John, are you sorry I'm so excited?" I asked.

"No," he replied. "It's good to see you engrossed and happy. But do you have to get so carried away?"

Instead of being fired up to a fully out of control hard bubbling boil, I think I'm getting the message he'd like it if I turned down the flame, let off some steam, and settled into a sweet and steady simmer.

I think I like the bubbling boil.

❃ The piano lesson ❃

Every seat in the concert hall was filled and the gathered audience was eagerly anticipating the start of the highly acclaimed master maestro's piano performance.

People seated near each other excitedly discussed the planned program and the musician's talents to help fill their final anxious moments.

One mother in the crowd, caught up in a captivating conversation, momentarily lost track of her young son. Quickly the boy made his way up the side steps of the stage and, with a gleam of mischief in his eyes, began plinking the familiar rhythmic notes of, you guessed it, *Chopsticks.*

As a hush swept across the audience, the appalled mother got up from her seat and started toward the stage.

Soon the muffled sound of snickering could be heard as the crowd realized the comedic aspect of the situation.

From his backstage dressing room, the maestro also heard the familiar melody. Quickly he grabbed his jacket and hurried to the stage.

Arriving at the piano quicker than the mortified mother, the celebrated artist extended his arms around the boy, placed his hands on each outer edge of the keyboard, and began improvising a melodic accompaniment to complement the child's efforts.

All the while this duo played, the master kept whispering in the child's ears, "Don't stop... Keep going... Don't give up... Don't stop... Keep going... Don't give up..."

❃ ❃ ❃ ❃ ❃ ❃

I heard this reportedly true story at a businesswomen's luncheon I attended and have continued to ponder the important lesson it conveys.

How many times have we failed to achieve a goal or an accomplishment because we gave in to discouragement, quit trying, and stopped too soon?

Maybe success surpassing our grandest vision was waiting right around the bend, barely hidden from view.

Rather than offering encouragement, how often have our words dealt the ultimate death blow that caused another to give up?

Many children are fortunate enough to be able to take voice or instrumental music lessons.

Almost as many parents, admittedly to protect their sanity, have discouraged their young and struggling aspiring musician, saying, "*Please* stop." Frequently this plea is uttered and heard long before excellence is even afforded an adequate opportunity to develop.

As adults, we often eagerly attempt a new task or embark on a stimulating challenge only to quickly encounter difficulty and struggle. Often we persevere and continue on only to find the obstacles increasing and the desired outcome ever harder to bring into focus.

Soon it becomes obvious that the easiest course of action is to surrender.

Throw in the towel.

Give up.

❈ ❈ ❈ ❈ ❈ ❈

How different the outcome might be if during those times of discouragement we were fortunate enough to have a caring friend, a co-worker, or a master come alongside offering gentle words of encouragement to bolster our perseverance.

The next time you or I find another in need of inspiration and hope, may we be willing to deter from our course long enough to make a difference by coming alongside with the offering, "Don't stop... Keep going... Don't give up... Don't stop... Keep going... Don't give up..."

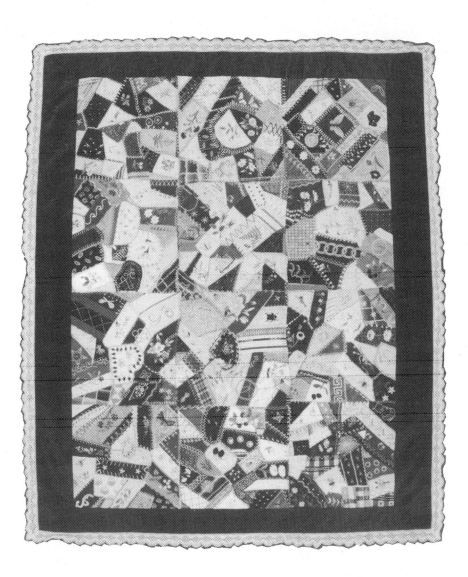

Meet The Author

With open and honest candor, **Jan Keller** writes about life's dramatic and mundane everyday occurrences. Discover yourself in her private, personal and poignant reflections, and relate to the myriad of emotions she so eloquently expresses. Through the pages of this book you'll laugh with, cry with, and relax with Jan as she embraces and draws you into the quiet recesses of her heart.

Jan's popular and award-winning column, 'The Syncopated Beat', appeared in *Ranchland News* between 1985 and 1996, and she has a following of loyal readers and fans. Through this book an ever-widening audience will have the opportunity to discover Jan's ability to put the universal hope of the human spirit into words.

A Colorado native, Jan grew up on a dairy farm northeast of Greeley. She and her husband John reside in Calhan, right in the heart of the sprawling Pikes Peak Plains Region east of Colorado Springs. They are the parents of two grown sons.

As a public speaker, Jan shares life's goodness through her warmth, humor and personal reflection.

Inquiries Should Be Directed To:

Black Sheep Books & Publishing
P.O. Box 325
Calhan, CO 80808